Fixing the World

Fixing the World

Jewish American Painters in the Twentieth Century

ORI Z. SOLTES

Brandeis University Press

PUBLISHED BY UNIVERSITY PRESS OF NEW ENGLAND

HANOVER AND LONDON

Brandeis University Press

Published by University Press of New England, One Court St., Lebanon, NH 03766

© 2003 by Brandeis University Press

All rights reserved

Printed and bound in Spain by Bookprint, S.L., Barcelona

5 4 3 2 1

Library of Congress Cataloging-in-Publication Data

Soltes, Ori Z.

Fixing the world : Jewish American painters in the twentieth century /
by Ori Z. Soltes.

 p. cm. — (Brandeis series in American Jewish history, culture, and life)

ISBN 1–58465–049–4 (alk. paper)

1. Jewish artists—United States 2. Painting, American—20th century.

I. Title. II. Series.

ND238.J4 s65 2002

759.13'089'924—dc21 2002009945

This volume was published with support of Beth Green Pierce and the PHILIP & MURIEL
BERMAN FOUNDATION.

Frontispiece. R. B. Kitaj, *The Painter (Cross and Chimney)*, detail, 1984–1985. © R. B. Kitaj, courtesy, Marlborough Gallery, New York.

Figure 30. Jack Levine, American, b. 1915, *Adam and Eve*, 1959, oil on canvas, 121.9 ˘ 107.9 cm, Gift of Michael Abrams, 1978.1349 The Art Institute of Chicago, All Rights Reserved.

Brandeis Series in American Jewish History, Culture, and Life

Jonathan D. Sarna, *Editor*

Sylvia Barack Fishman, *Associate Editor*

Contents

Preface

From drawings to paintings to installations, visual art in the twentieth-century United States has been marked by an explosion of productivity by Jews. This book offers a discussion of some of the Jewish American painters who exemplify this explosion. Where they fit into Western art—which has been largely Christian art for the past sixteen centuries—is one of the key questions asked by Jewish artists in the course of the century. In the United States, they have also asked where they fit into American art. In the second half of the century, exponentially increasing numbers found it impossible to avoid addressing the Holocaust. So, too, in recent decades, many have raised questions regarding the development of Judaism itself. Jewish women artists have been a spectacularly prolific part of those decades and increasing numbers have harnessed their work to the question of where women fit into a Judaism that traditionally excludes their gender from much of its essential ritual life. Various Jewish artists, in turn, have focused on the Torah and more broadly on Jewish textuality in visual terms. Others have created a stunning array of newly conceived traditional ritual objects, while some—women in particular—have been creating new precedents for ritual objects, such as *Miriam Goblets*, which balance the Elijah's Cup on the Seder table and celebrate the sister of Moses, whose role is traditionally minimized when retelling the story of Passover.

From the time of immigrant artists early in the twentieth century to those flourishing at the edge of a new millennium, across varied media and styles, a prevailing theme has been the interest in the *social*, and not merely aesthetic, import of art. While this interest is not absolute, it is present to a pronounced degree among Jewish American artists. This connects to the concept of *tikkun olam*—repairing or fixing the world—that is repeated by centuries of Jewish thinkers. That concept articulates the obligation for us to help perfect an imperfect world; many have viewed art, in part, as a medium through which to express *tikkun*.

There are particular ideas and issues that seem to define each era, and although the chapters that follow loosely yield to a chronological ordering, themes jump from one decade to the next, (particularly since so many artists are active across many decades without necessarily changing their focus), so

the timeline is necessarily approximate. So, too, although this book focuses on twentieth-century American painters, the introductory context turns to a handful of European painters, one key Paris School sculptor (who lived much of the last three decades of his life in America) and one late nineteenth-century American sculptor.

This study is not comprehensive, even within the limited context of painters who are Jewish and American in the twentieth century. There are simply too many talented artists at work, particularly as one surveys the last twenty-five years of the century and the beginning of the new millennium. I have included most well-known painters and many less well-known ones whose work I have encountered in my years as a museum director and curator, and which deserves to be before the public. I left out many more whom I would have preferred, with more space, to have included.

I have sought in my choices to present a sense of the array of ideas and stylistic proclivities or questions that have been explored by Jewish American painters in the past century, but rarely was I even able to encompass the breadth of focus of any given artist. None is treated fully enough: Each discussion must be viewed as partial. If the last hundred years have been the beginning of an unprecedented dynamic era for Jewish artists in America (and elsewhere), this book presents a beginning of exploring that era.

Nearly two decades ago, Rex Moser, then Director of Education at the Art Institute of Chicago, first encouraged me to wrestle with the question of "Jewish Art." Two years later, the combined talents of I. Leonard Kaplan, Budd Margolis, James Bonnett, and Eric Schneider made possible a thirteen-hour video series on that subject. These individuals in particular deserve credit for helping me to lay the foundations of thinking along lines that ultimately led to this book, so many years later. I thank them profoundly, as I do artist Joyce Ellen Weinstein, who brought the University Press of New England and me together.

Washington, D.C. O.Z.S.

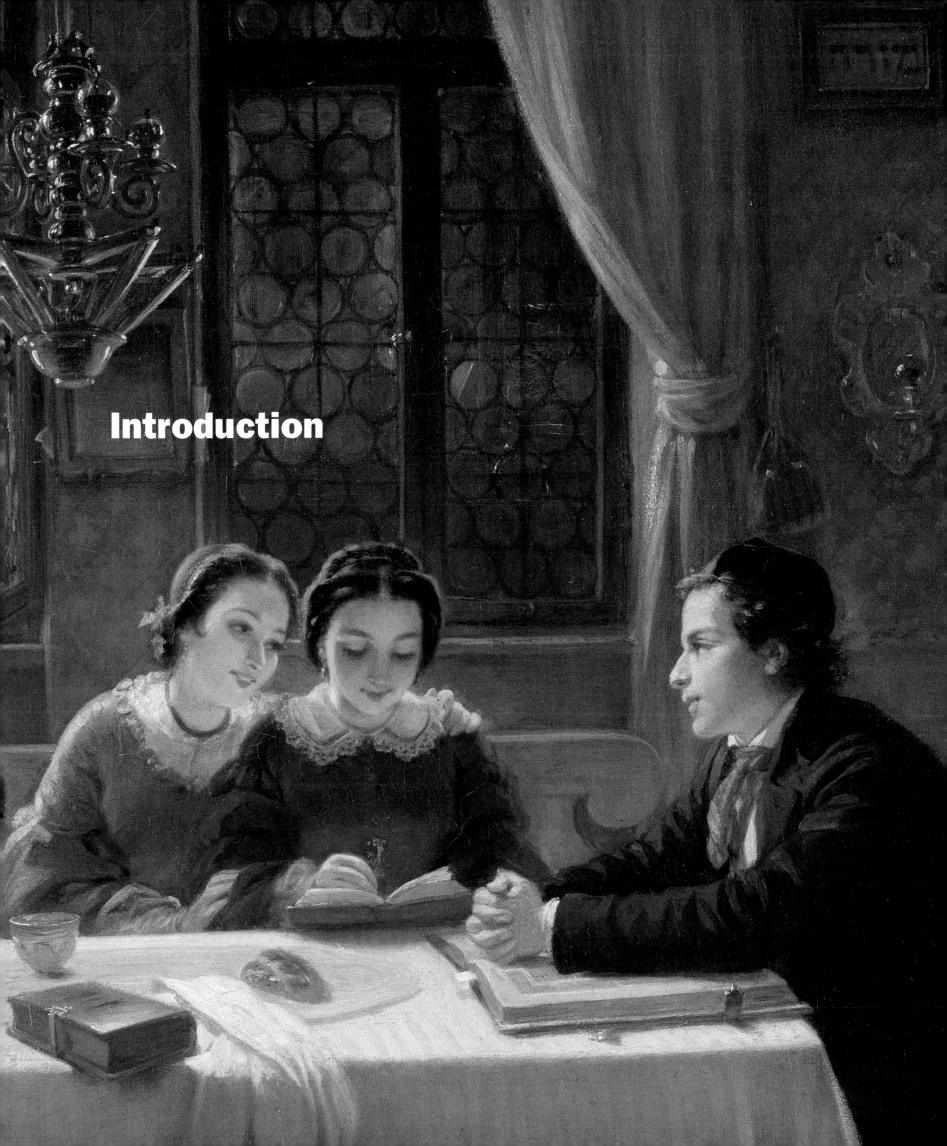

Introduction

The Problem of Jewish Art

It is perhaps impossible to define Jewish art, but addressing that difficulty is important as a context in which to consider Jewish American painters in the twentieth century. Defining "Jewish" is conceptually and historically complex. Judaism as we recognize it—with its Bible, its prayerbook, its life and festival cycle, its rituals—crystallized only after the destruction of the Temple and the Bar Kochba Revolt. To refer to Abraham the *Hebrew* or Moses and David the *Israelites* or Ezra the Scribe the *Judaean* as Jews is anachronistic. Yet to speak of Judaism as if it began less than two millennia ago is also incorrect: It is an edifice built on Hebrew-Israelite-Judaean foundations.

By the late fourth century, the matter became buried by the political triumph of Christianity. There seemed little need to define Judaism between that time and the late eighteenth century, beyond articulating the spirituo-legal obligations that it emphasized, separating it from other religions. But the issue resurfaced two centuries ago in the wake of Emancipation. It remains a conceptual conundrum in our own time: Are Jews a religion, a nation, a people, a civilization, a culture, a body of customs and traditions? Most Americans think of Judaism as a religion. Others, particularly secular Jews, think of Judaism as a culture. In the former Soviet Union, Jews were regarded as a nationality. Mordecai M. Kaplan, founder of the Reconstructionist movement, referred to Judaism as a civilization.

When does Jewish *art* begin? There is no easy chronological crutch upon which to lean, since the precise beginning point of Judaism is not easily located. The crutch of geography is also unavailable. Italian art is, ultimately, definable as art made in Italy. French art is art made in France and Spanish art is art made in Spain. What of *Jewish* art? There is no "Jewland." Before the time of Judaism, there was a *Canaan*, a *Yisrael*, a *Judaea*—which after the Bar Kochba Revolt was called *Palestina* by the Romans. When that same land was reclaimed eighteen centuries later, it was again named Israel (*Yisrael*), not "Jewland"—alluding, for ideological reasons, to a glorious, non-diasporatic Biblical past. Citizens of that modern secular (yet, paradoxically, Jewish) state—and its artists—are not only Jewish. They are Muslim and Christian and Baha'i and Druze (among others). The definition of *Israeli* art does not answer the question of what *Jewish* art is.

And how do we define *art*? Throughout most of history, art has served religion as the visual concomitant of prayer and myth, to express, represent and convey divinity and its relationship to us. Not so in Judaism, which regards God as invisible and thus visually unportrayable. If Jewish art is not religious art in the usual sense, what *is* it?

Art is also the reflection of objective reality filtered through the artist's expe-

(Preceding page)

Sabbath Afternoon (detail) Moritz Oppenheim (1800–1882) Frankfurt am Main, ca. 1866. Oil on canvas. Gift of the Jewish Cultural Reconstruction, Inc. HUCSM 41.135. From the HUC Skirball Cultural Center, Museum Collection, Los Angeles, CA. Photography by Marvin Rand.

rience and perceptions. Yet Jewish perceptions and experiences are markedly different over time and place. How does one compare the experience of a contemporary American Jew with that of European or Middle Eastern Jews in other eras? To speak simply of Jewish experience as diverse, or as an experience of dispersion ("the diasporatic experience") is insufficient to shape a solid definition of Jewish art.[1]

When one uses the phrase "Jewish art," is one's criterion of definition the *art*—and does one then refer to its style or its symbols, its subject or its purpose, its content or its intent? Some symbols, such as the seven-branched candelabrum, appear throughout the centuries as "Jewish," while others, such as the six-pointed star, became universally recognized as "Jewish" only in the late nineteenth century. Or is our criterion the identity of the *artists*—in which case is it the artists' family of origin or their convictions as Jews to which we refer? Must they *consciously* be making art that expresses Judaism or Jewishness? What of a convert into or out of Judaism—does his or her art suddenly become or cease to be Jewish?

Jewish Artists after Emancipation

Prior to the late seventeenth century, most "Jewish" art was ritual art, although, for various reasons, Jewish ritual objects throughout Europe were rarely actually made by Jews until the nineteenth century. The Jewishness of these objects was thus a function of purpose, not of who made them or of their stylistic features. Painting and sculpture, which are the glory of Christian art, were not found in Jewish contexts, since the depiction of God, which all but defines Christian art, is forbidden in Judaism.

The issue became both simpler and more complicated with the proliferation of Jewish artists working in non-ritual media in secular/Christian Europe during the past few centuries. Is a portrait of a Jew by a Jewish artist more a work of Jewish art than the portrait of the same Jew by a non-Jewish artist or than the portrait of a non-Jew by a Jewish artist? One might say that Rembrandt's sensitive etched portraits of Rabbi Manasseh Ben Israel of Amsterdam, in the 1640s, convey the latter's Jewish soul far more effectively than does the pedestrian rendering of him by the Jewish artist Salom Italia. Or did Salom Italia better know the coldness of Manasseh, Spinoza's teacher and eventual excommunicator, and express it in his portrait, whereas Rembrandt saw the rabbi from the perspective of an idealizing outsider as a more benign and venerable figure?

This issue became more intriguing with the emancipation of western Jewry in the late eighteenth century, and developed further in the course of the nineteenth

century. In an emancipated world, how would Jews find their place? How should Judaism respond to a new situation, of being less circumscribed than before, of being permitted to be part of the mainstream and not on the outer edge of society? To what extent would abandonment of traditional religious ritual and practice be necessary in order to fit into Christian (even as it called itself "secular") Europe?[2]

Moritz Daniel Oppenheim

In this context, nineteenth-century paintings of Jewish genre scenes by Jewish painters lend themselves to easy inclusion within the rubric "Jewish art" by virtue of their subject matter. *Yom Kippur in the Synagogue*, by Mauritzy Gottlieb (1856–1879), is an obvious example, in which the artist has placed himself in the center, looking dreamy as the Torah is carried forth among the congregation. *Sabbath Afternoon*, by Moritz Daniel Oppenheim (1799/1800–1882), the first unbaptized Jew to achieve success beyond the momentary as a visual artist, is another (fig. 1).

Oppenheim's painting, created about 1850, in part reflects the layered issue of identity that confronted mid-nineteenth-century, middle-class, Central and Western European Jews. It presents a post-Emancipation meeting of old worlds and new. The artist has divided his canvas. He has created an arch of darker col-

Fig. 1.

Sabbath Afternoon Moritz Oppenheim (1800–1882) Frankfurt am Main, ca. 1866. Oil on canvas. Gift of the Jewish Cultural Reconstruction, Inc. HUCSM 41.135. From the HUC Skirball Cultural Center, Museum Collection, Los Angeles, CA. Photography by Marvin Rand.

ors in which the young people are encompassed, while the old grandfather leans away from that semi-circle and is dressed in contrastive white (in one version of the painting). This last feature, of light-hued apartness, is further emphasized by the stream of light pouring in from the window that bathes the old man—as, eyes closed, he is bathed in afternoon dreams. Perhaps he dreams of the past. Perhaps he is listening to his grandson reciting a Bar Mitzvah speech, yet he is disconnected compositionally from the family.

Although the child faces out toward his grandfather and thus in one sense toward his grandfather's world, he is ultimately part of the present and the future, not the past. Formally, he remains encompassed by the dark-hued arch of the "modern" generation. Seated at the post-Sabbath-meal table, a young man engages in a traditional, centuries' old Sabbath afternoon activity: expounding a page of *gemara* or perhaps of Rashi. But this is the *modern* world: The setting is not the House of Study—it is the female-dominated dining room. And the audience contains not fellow-scholars but women. It is a new world, in the process of transforming tradition. Oppenheim has captured a moment that reflects the tension between ghetto-bound medieval Jewry and the modern world so many Jews wished to embrace. Its content defines this work clearly enough through its narrative possibilities as a "Jewish painting."

Camille Pissarro

But what happens to that ease of categorizing when we turn to an impressionist landscape by Camille Pissarro (1830–1903)? The work of Pissarro, one of the founding fathers of French impressionism, was eclectic and experimental. Close associate of Monet and Renoir, he was fascinated with color and light theory. His subjects are diverse and his style reflects multiple influences, from English and seventeenth-century Dutch landscape art to Courbet's palette-knife and color schemes. Perhaps his tendency to eclecticism, his broad-ranging interest in diverse influences, could be linked to the universalist inclinations of a Jewish artist who felt himself a citizen of the world. And perhaps Pissarro's bookish proclivities (he alone among the impressionists read the scientific literature on the diffraction of light so essential to impressionism) was part of the long-term Jewish tradition of textual focus.

Pissarro also expressed the idea that artists have a social and not only an aesthetic responsibility. This notion emerges in the modern era as a feature of much of the art created by Jews. He believed that the advances and discoveries uncovered for painting—such as issues pertaining to how we see or how light may be understood to break up into colors—must be shared with the community at

Fig. 2.

Camille Pissarro, *Woman in the Orchard*, 1887. Oil on canvas. Private collection.

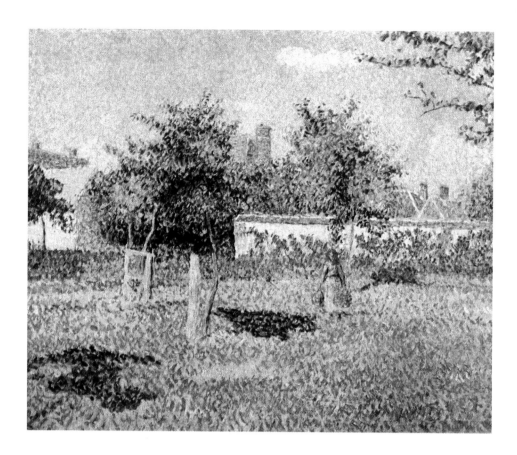

large.[3] The matter-of-factness of works like *Woman with Cow* (1874) recalls the socio-visual agenda associated with contemporaries such as Millet. But Pissarro's peasants are not romanticized as Millet's are, they are simply observed. Such portrayals perhaps echo patterns of thought from within his heritage: long-suffering enough to be sympathetic but not romanticizing.

In any case, such a consciousness set Pissarro apart from other impressionists, as did his willingness to continue to experiment with varied painting styles. When impressionism finally achieved acceptance and the others rejected younger artists like Gauguin and Seurat, Pissarro accepted them—even trying the *pointillist* style created by Seurat in the mid 1880s (fig. 2). In other words, he was an ongoing revolutionary against orthodoxy—against whatever had come to be accepted as "proper" art.[4] Although all of the impressionists began as revolutionaries, only Pissarro continued when the others had found their comfort zone. Renoir criticized "that Israelite Pissarro" for giving access to the impressionist "circle" to the younger artists once that circle had been securely shaped. Ironically, even the younger artists, Gauguin and Seurat himself, eventually broke with him, unable to keep up with Pissarro's experimentalist ideology.

So is Pissarro's art "Jewish"? His concern for the emancipation of artists as part of the larger search for human freedom; his insistence on the relationship between artistic progress and human progress; his openness, his experimentation; his social-aesthetic consciousness; his intellectuality—these elements invest his

canvases. Do they derive from a Jewish consciousness? His contemporaries seemed to think so. To them, as he strolled down the Paris streets sketchbooks in hand, he was "Moses with the Tablets of the Law." In any case, the work of that "Israelite Pissarro" began the substantial contribution by Jews to the shaping of the visual arts in the twentieth century.

Jewish Artists in the "Paris School"

Boris Schatz (1866–1932), court painter and sculptor to King Ferdinand III of Bulgaria, motivated in the early twentieth century by the Zionist effort to reclaim Jewish national (as opposed to religious) roots, specifically asserted the importance of shaping a Jewish national art. With the support of the Zionist leadership, he founded an arts academy in Jerusalem in 1906. Called Bezalel, the school was named for the artisan credited at the end of the book of Exodus with devising the Tabernacle in the wilderness to house the Tablets of the Law that Moses had brought down from Sinai. Schatz's efforts, though, would not yield a generalized Jewish national art as much as what would later evolve as Israeli art.

Contemporary with the early Bezalel period (1906 to 1929) was the "Paris School," home to a significant number of Jewish artists. Paris in the early twentieth century gave birth to—or hosted—virtually all the elements of the modernist revolution in the visual (and other) arts. Jewish artists, particularly from Eastern Europe, felt comfortable in a city where one might be an outcast as an *artist*, rather than as a *Jew*. Moreover, the recently resolved *Affaire Dreyfus* had left the rancid odor of antisemitism in Paris; Parisians were anxious to expunge it through hospitable behavior toward Jews.

Chaim Soutine

One of these was Chaim Soutine (1884–1943), arriving from Lithuania in 1910. The City of Light offered him the opportunity to be a visual artist when the very traditional Orthodox Lithuanian Jewish world from which he came did not. That interpretation of the Second Commandment that forbids any kind of image-making was strong enough in his community that his brothers beat him up whenever they found him drawing.[5] Paris was freedom from both the non-Jewish *and* the Jewish worlds he had left behind.

Soutine's lack of confidence is clear from his self-portraits, which exaggerate his facial features into caricature and invariably deny his hands, so important, with the eyes, as instruments for the artist. His 1922–1923 *Self-Portrait* turns his lips

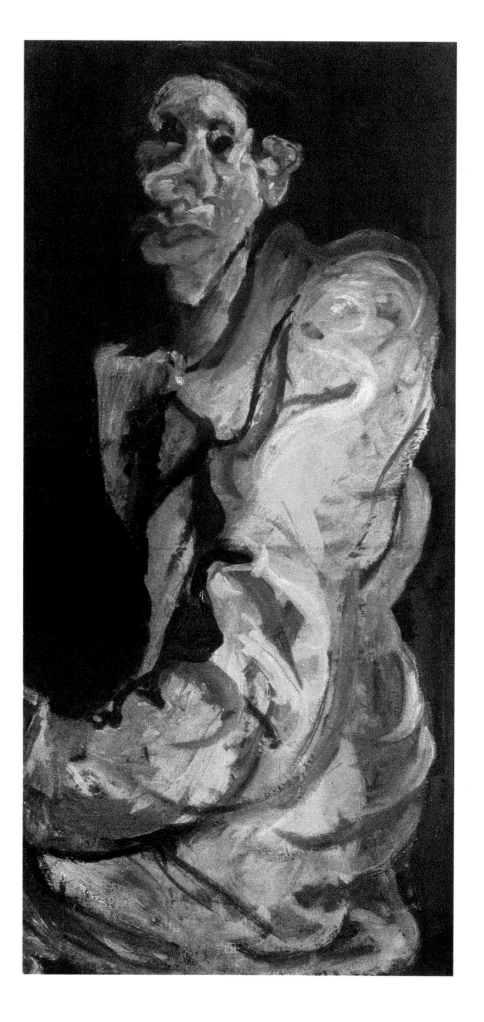

into sausages and his body into an endless blob of yellow, particularly the grotesque arm from shoulder to wrist—for the canvas edge brutally cuts off the hand (fig. 3). Was that color—the habitual choice in Christian art through the ages for tying the image of the Jew to that of Judas, the betrayer of Jesus—an arbitrary choice? Did the artist, consciously or not, refer that sensibility to himself—and perhaps not as much to himself as a Jew still saddled with the traitorous Christ-killer label, but as a traitor to the Judaism so completely abandoned by him in the secular ambiance of Paris?

Soutine applied visually violent sensibilities to his entire range of subjects, from portraits to blood-red still lifes, hanging beef-carcasses and flayed oxen that suggest anonymous crucifixions. Is this tortured commentary by a secularized Jew a reference to the human condition? Is the commentary made particularly possible by a Jewish sensibility honed by the experience of pogrom-ridden Eastern Europe? His work is certainly prophetic of the fate of European Jewry in the following decades.

Soutine was the quintessence of the alienated artist. As a "Border Jew," a *Grenz Jude*, he was emphatically estranged, isolated between worlds he couldn't bridge—the Lithuanian, the French, the secular-Christian, the Jewish—and in none of which he ever felt fully comfortable. If the possible reflections of Pissarro's Jewishness are his eclectic searching, his intellectuality and social consciousness, his open-mindedness and sympathy for the downtrodden, then the visual reflection of Soutine's Jewishness may be his radical discomfort with the world around him.

Marc Chagall

Very different is the work of Marc Chagall (1887–1985), who came to Paris from Russia, a world not so far removed from Soutine's Lithuania. But Chagall's was a happier experience. His family didn't stop him from becoming an artist, and perhaps even encouraged him. His canvases are alive with memories of Vitebsk, his hometown. Indeed, the dual filters of his memory and his imagination transform Vitebsk from a grey and brown reality into a romanticized dream world, a circus of color. No painter of the twentieth century, except perhaps Matisse, can lay claim to a more stunning palette. The bright lights of Paris are splintered into all of the brightest tones of the spectrum. The city has turned him upside down and inside out and on his canvases he has returned the favor. Monuments swirl and people float. Past and present merge in his work; Vitebsk and Paris mirror each other.

In direct antithesis to Soutine's self-denying self-portrayals, Chagall's are full

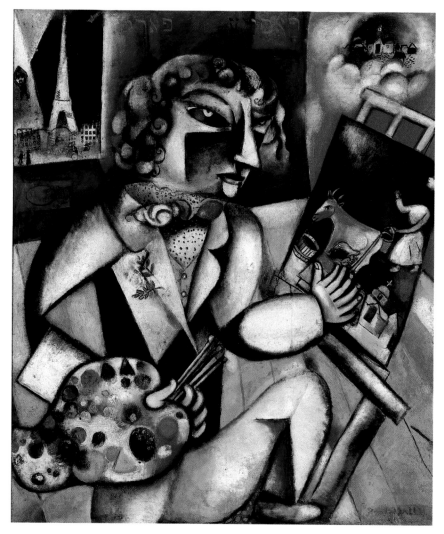

of self-confidence. Perhaps the most extraordinary is an early one, from 1911–1912: a *Self-Portrait with Seven Fingers* (fig. 4). It adds a *soupçon* of Cubist spice to the Russian icon/Paris fauve color stew with its combination of Paris through the window and surrrealistic Vitebsk in the clouds rising from the orange walls within the studio. The words "Paris" and "Russia" are written in Yiddish above the artist's head and a painting of Russia rests on the tilting easel. With one hand, the artist grasps a whole cluster of paintbrushes; the other gives the painting its name. It is not only the exuberance of youthful creativity in the city of creativity *par excellence* that reverberates from that hand—as if the normal complement of fingers is insufficient to accomplish all that the artist wants to do—but perhaps not by accident, the hand becomes the oldest, most consistent symbol in Jewish art: the seven-branched candelabrum.

The seven-branched *menorah* frequents Chagall's work, although often in indirect visual terms. His sense of ease at mixing and merging Jewish and Christian symbols again and again bespeaks the relative comfort with which he bridged those two religious sensibilities. All of which makes his painting *White Crucifixion*" (fig. 5) particularly stark as a divergence from his usual Jazz Age brightness.

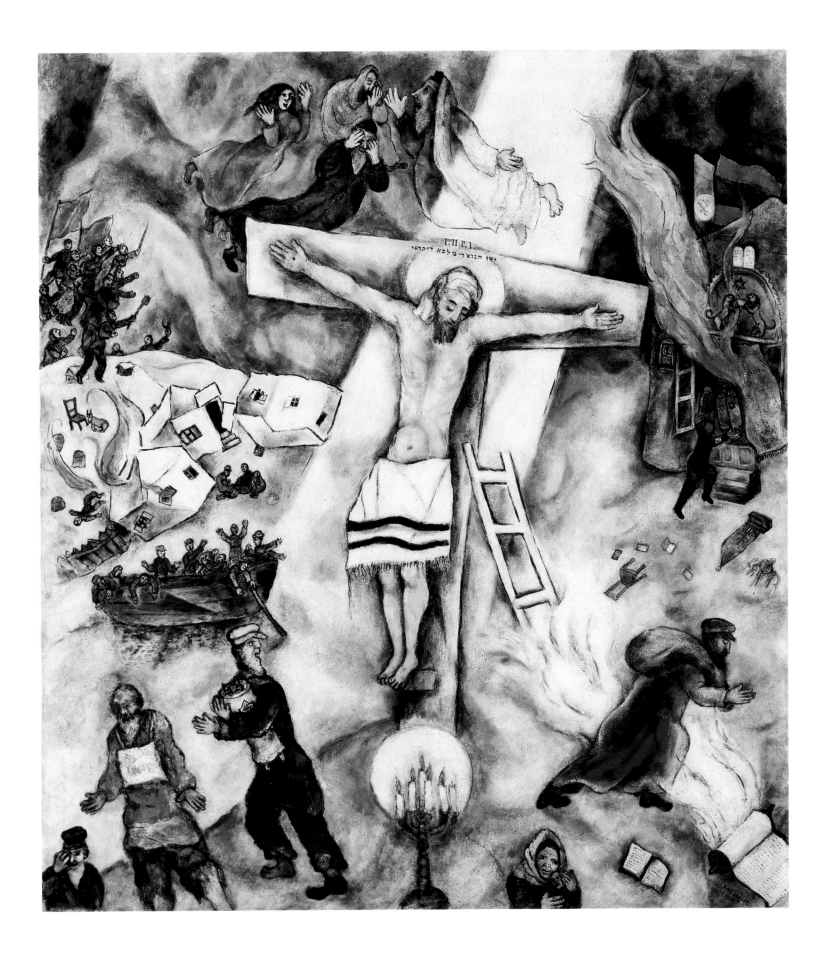

Painted in 1938, the year of *kristallnacht*, the work takes on the most consistent symbol in Christian art, and, in re-visioning it, creates a deeply Jewish work.

"White Crucifixion" is aswirl with both white light and violence: Nothing is happening in the shadows, hidden from the world's view. A synagogue is on fire, a village is topsy-turvy (as in many of Chagall's canvases), figures flee with packs on their backs or Torah scrolls in their arms, Jewish elders hover in horror (where in a traditional Crucifixion, angels might be depicted weeping). More striking still, Christ is wrapped in a loincloth that looks remarkably like a Jewish prayer shawl, a *tallit*. A Torah in the lower right hand corner of the canvas, falling out of the picture plane, emits a lush white fire (rather than being consumed by it), which licks at the foot of the ladder leaning against the cross. In traditional Christian art, such a ladder would be part of the deposition, and Nicodemus and/or St. Joseph of Arimathea would be lovingly and carefully removing the body from the cross. The ladder here is not only empty, but is surrounded by an enormous empty space, the only empty space on the canvas.

The sum offers us a dark vision out of the brightness: This is not the Savior of humankind, but a suffering Jew for whom there is no redeemer and no salvation. The *menorah* at Christ's feet confirms this pessimism. It offers only six candles. The redemptive seventh candle, related to the idea of the seventh day as holy and in turn to the Divine commandment to keep it as a day of rest—thus centering the Covenant between God and Israel, with all of its promises and responsibilities—is missing. The bright white light that dominates the painting is conceptually dark.

Amadeo Modigliani

Amadeo Modigliani (1884–1920) arrived in Paris in 1906 from Italy. His overt Jewish connection was distinct but limited. Bar Mitzvah at age thirteen, he soon gave up formalized Judaism—as he did other formal studies such as Greek and Latin—to focus on his development as an artist. He pursued his ambition in the art school of his home city, Livorno (Leghorn), and later traveled to Florence, Rome, and Venice, absorbing both their Renaissance artistic essences and their cosmopolitan sensibilities. He developed an interest in symbolist poetry and shaped a self-image as a romantic outsider-artist—an *artist maudit*. With such a mindset, he arrived in Paris to pursue his goal among the many artists inhabiting Montmartre and the cafés of the Rue Lafitte. Modigliani produced his first oil in 1908, at least the earliest that has survived: *La Juive* (*The Jewess*, fig. 6). Reminiscent in its coloration of Picasso's early blue period, its nervous brush strokes

Fig. 6.

Amadeo Modigliani, *La Juive*, 1908. Oil on canvas. Private collection.

thickly cover some areas, thinly covering the ground, indicating Modigliani's interest in sculptural effects.

La Juive thrusts before us the question of the Jewishness of Modigliani's art: Without the title, would we view the features of *La Juive* as particularly Jewish? More Jewish than, say, Rembrandt's depictions of Jews? If we call this work "Jewish," it is because of the criteria of subject, established by title, and artist identity. Neither style nor symbol would suggest such a classification, and more importantly, observing its "Jewishness" does not preclude other aspects of its identity. Modigliani found his sources in Manet and Cézanne and Brancusi, and in the Italian Renaissance tradition of Duccio, Botticelli, and Parmagianino, as well as in African Art.

But Modigliani arrived in a Paris just ending its notorious Dreyfus affair with

Fig. 7.

Amadeo Modigliani, *Paysage du Midi*,
1919. Oil on canvas. Private collection.

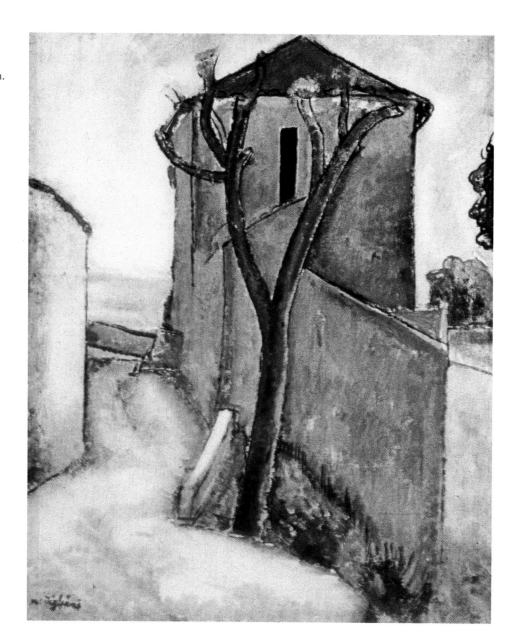

its anti-foreign, anti-Jewish overtones. In Paris, he developed an enlarged sense of his (secular-cultural) Jewish identity.[6] In hawking his drawings to strangers in Paris cafés, he introduced himself as "Modigliani, *Juif*"—"Modigliani, Jew." Most of his friends among the artists were Jews: Moise Kisling, Max Jacob (who subsequently converted to Catholicism), Chaim Soutine, Jacques Lipschitz. By 1911, he had moved into the impoverished artists' domicile, *La Ruche*, in Montparnasse. Overrun by diverse painters, poets, and sculptors, this beehive complex was dominated by Jewish artists who had come from the east: Ashkenazi speakers of Yiddish as well as Slavic and Baltic tongues whose presence reverberated for Modigliani a Jewish consciousness from angles and experiences emphatically different from his own.

Yet the issue of Jewishness is difficult to identify in Modigliani except at the beginning (*La Juive*) and the end of his life as a painter. For one of Modigliani's

most intriguing works—a rare landscape, done in late 1918 or 1919—is called *Paysage du Midi* (*Landscape of the South*, fig. 7). It was painted during his last spring journey to the south of France, together with Soutine and others, including Jeanne Hébuterne (his last significant female friend) and her mother.

Stylistically, the *Paysage du Midi* emulates Cézanne in the manner in which the artist permits canvas to show through the brush strokes and in the structure: foliage in the foreground, houses in the middle ground, a mountain (most frequently for Cézanne, Mt. Ste. Victoire) in the background—except that Modigliani has turned "foliage" into one lonely tree and telescoped buildings and mountain into a dismal, towering house with a dark window staring out. The motif of a road leading into the distance, which French landscape painting can trace back to Corot, is here a road leading nowhere.

This *Paysage du Midi* is no sun-splashed southern view. The acute depression of the artist is evident. The road leads, perhaps, to an Italy for which he reportedly longed (so his correspondence and the recollections of Soutine and Utrillo, his best friends, would suggest), but would never reattain in the few years of life left to him.[7] In his heart and imagination, Italy remained a childhood recollection that included in its halcyon aura an acknowledged Jewishness. This memory, perhaps, motivated the particular configuration that appears on Modigliani's canvas: the tree that dominates us bifurcates into two three-branched arms. Together with the house peak and dark, empty window, it presents a stylized seven-branched candelabrum—a *menorah* form—even to the two branches tipped by leaves that appear like glowing flames. With death beckoning, the ultimate traditional Jewish symbol of hope rises in the midst of his desperation, a symbol derived from warm memory and perhaps the depths of his unconscious, which brings him full circle back to an important part of where he began as an artist: as a *Jew*.

Jacques Lipchitz

Modigliani's friend, the Lithuanian Jacques Lipchitz (1891–1972), was perhaps the first major sculptor to translate the terms of cubism—reducing the form of an object to its constituent geometric parts and re-presenting it as pure line and angle—to the three-dimensional medium. Such deconstruction of form is originally the idea of Braque, Picasso, and other non-Jewish artists. What in Lipchitz's work might be construed as "Jewish"?

Ultimately, the issue rests on examining works one at a time for what might be termed the Jewishness of motivation beneath each. We might argue that Lipchitz's 1943 *Prometheus Strangling the Vulture* is Jewish—in a specific way

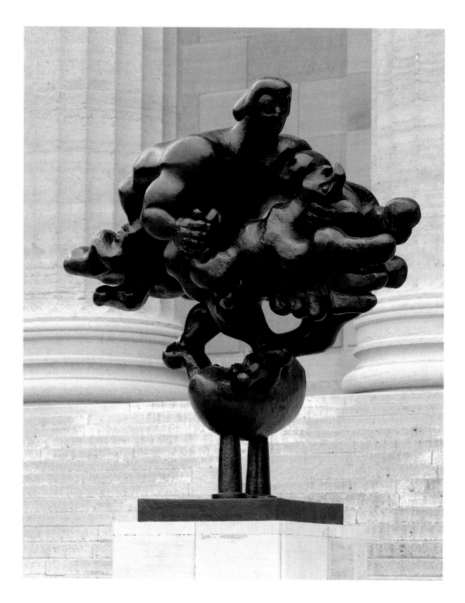

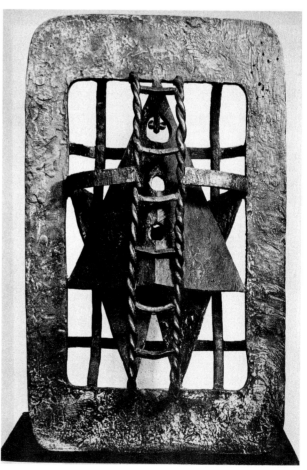

(fig. 8). The artist offers a Greek mythological figure, but not according to the standard story line of the myth. He has transformed the scene that features a messenger eagle sent by Zeus to tear at Prometheus's intestines into one wherein the Titan *wrestles* with a different kind of bird of prey. Lipchitz has presented Prometheus not as chained to the rock, but freely engaging this emissary. The work recalls, in a formal sense, the image of Jacob struggling with God's messenger angel, as a consequence of which the patriarch becomes—is renamed—Israel. Lipchitz has created his own *midrash*.[8] More precisely, he has synthesized two related but different ideas from two different sources in the foundations of Western civilization. And given the year of the sculpture, it is surely possible that the artist saw the titanic struggle as emblematic of the struggle against the Nazis, in which Prometheus would prevail over the vulture.[9]

In the two centuries since Emancipation, "Jewishness" has sometimes expressed itself as an overt struggle for self-definition. Lipchitz's *Pierrot Escaping* (1927) reflects this (fig. 9). Pierrot, a stock character from the *commedia dell'arte*, is the quintessential tragicomic figure: the clown who weeps inwardly while his antics entertain his laughing audience. But Lipchitz has turned Pierrot into a Jewish symbol by transforming the concrete figure of a man into the abstract form of a six-pointed star: the Star of David, which, by the beginning of the century was supplanting the *menorah* as the most recognized Jewish symbol. The artist has given the viewer a symbol of the Jew as tragicomic figure, in silent grief during centuries of oppression, offering a kind of entertainment within the theater of history.

Pierrot is shown trying to climb from a window. More precisely he is sandwiched between the window and the ladder—inescapably, since the ladder begins and terminates connected to the window frame. But even if Pierrot escapes from a room through a window, he will never escape being Pierrot. In Lipchitz's sculpture, the bars of the cast-iron window form a series of crosses, symbols of the Christian world of which both Pierrot and Lipchitz are part. The ladder of would-be escape is made of the same material as the window bars, as if to underscore the fact that it leads from nowhere to nowhere. His Pierrot-as-Jew remains eternally trapped between imprisonment and the *illusion* of escape, frozen between a world that, for all its pretense of secularization, is Christian, and the mistaken notion that there is a simple ladder out of his identity. In attempting to abandon his identity in order to fit into the larger non-Jewish world, the Jew is reduced to a two-dimensional image, a flattened six-pointed star.

Lipchitz's *Pierrot Escaping* not only revisions a universal symbol (Pierrot) as Jewish (a Star of David). By imbuing a concrete three-dimensional figure with an abstract two-dimensionality, the artist offers both artistic and social commentary

without creating a "graven image for worship." But his "Jewish universalism" extends further. In 1958, the artist's sketch for the *Gate for the Roofless Church* in Harmony, Indiana, would submerge the ultimate Christian symbol—the cross—within four wreath-like circles. Without beginning or end and without stops and starts such circles symbolize perfection in many cultures. These particular circles, in being offered by Lipchitz four times, simultaneously reflect the importance of fourness for Christian thinking, (the number of the Gospels, and the arms of the cross itself), and the focus in Jewish mysticism on the problem of how to express the invisible God. God's perfection might be expressed as a circle. But fourness is in particular associated with God by the Kabbalists, for there are four letters in God's ineffable Hebrew name. Thus this sculptural idea synthesizes Jewish mystical thinking with general and Christian thinking in visually concretizing the relationship between divinity and humanity.

Lipchitz's Jewishness is a frequent presence in his work, interwoven with other aspects of his experience and thought. *Sketch for the Roofless Church* was the successor to an earlier Christian commission, upon which he began work in 1948. The *Notre Dame de Liesse* includes on its base, at the artist's insistence, the inscription that this shrine for the Madonna was created by "Jacob Lipchitz, a Jew, true to the faith of his ancestors." It reflects Lipchitz's sense of gratitude to an America to which he had arrived as a refugee in 1941, and the possibilities that he perceived here, to be simultaneously a Jew, an American, an artist, a human being—without the impossible challenge to such a combination that even Paris offered with the arrival of the Nazis.

The Turn to America

Moses Jacob Ezekiel

Among the handful of Jewish artists making an impact on the visual world that Lipchitz would transform was the American sculptor Moses Jacob Ezekiel (1844–1917). He was the first American Jewish artist in any medium to achieve international recognition. Born in Richmond, Virginia, the artist traveled to Berlin in 1869 to study sculpture. As the first foreigner to win the Michel Beer Prix de Rome from the Berlin Academy of Fine Arts, in 1873 he settled in Rome, where his studio at the Baths of Diocletian remained for over forty years a meeting place for artists and actors, musicians and poets, politicians and princes.

Ezekiel won the Rome Prize for a bas-relief sculpture called *Israel* (fig 10). "I cut the name 'Israel' in the lower edge of the frame," he wrote, "although Aha-

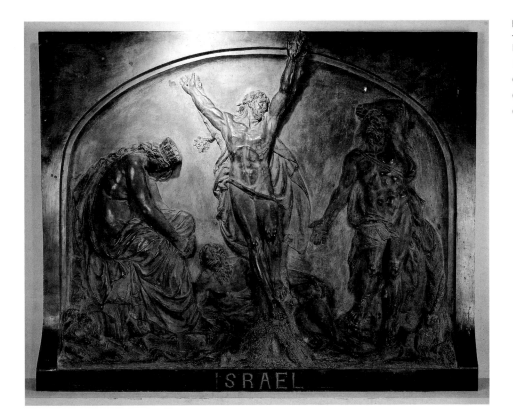

Fig. 10.

Moses Jacob Ezekiel (1844–1917)
Israel-1904. Bronze relief, h. 44 x w.
66 in. Hebrew Union College collection,
67.62. Skirball Museum, Cincinnati.
Copy of lost 1873 original.

suer would have been just as appropriate . . . Ahasuer is the traditional name of the Wandering Jew who is the type of Israel and the Wandering Jew gives the key to any understanding of my relief." Yet he continues elsewhere, "Ahasuer's agony is the type of *all* human woe . . . [it] is the hope of redemption that throbs in *every* human heart; it is an allegory founded upon the history of Israel."[10]

While he was praised as the greatest talent since Michelangelo by contemporary critics, Ezekiel's heroic Israel, a heroic Jesus, a massive allegory of Jerusalem and her fallen kings were applied to a Jewishly conceived universal subject. The artist has placed a traditional Christian theme, the Crucifixion, ordinarily flanked by defeated Synagogue and Church triumphant, at the disposal of a different sensibility. Even in despair, the figure of Israel surges up and out toward the viewer in muscle-bound nobility, his outstretched right hand echoing the diagonal of the crucified Jesus' upreaching left arm, the counterpoised leg of the one figure mirroring the other, underscoring the relationship between the two as sufferers. By his title, Ezekiel angles the focus of the viewer away from the center occupied by the crucified Christ, indeed suggesting for a moment that the figure being crucified *is* actually Israel, since that is the title of the work inscribed by the artist; ordinary logic would incline the viewer to associate the title with the dominating central figure.

The subject of Jesus would occupy Ezekiel a number of times. *The Martyr* (1876) is a bust of Christ "born and bred a Jew," as the artist wrote. With his *Christ in the Tomb* (1889), "I wanted to make the greatest Jew and the greatest reformer

of millions of people." Contemporary Christian critics commented in amazement that a Jewish artist had so stunningly conveyed the calm nobility of Jesus. What we see for Ezekiel is a compelling artistic consequence of assimilation after Emancipation: the appropriation and re-exploration of the most Christian of Western art historical themes. He has re-presented Jesus as a symbol neither of God, as he would be for Christians, nor of oppression and persecution, as he would be for Jews, but of human nobility, enhanced and highlighted by suffering.

Even as Ezekiel remained a resident of Rome, much of his work continued to reflect on America. By the time of his death in 1917, young Jewish artists from America were coming and going within Western Europe (especially within Paris) like their non-Jewish American and Eastern European Jewish counterparts. But increasing numbers of European-born Jewish would-be artists and those fated to become artists were making their way across the Atlantic to America.

Which brings us back to the beginning, and moves us forward. For American Jewish artists, both the immigrants and those born in America, share as rich a diversity of style and focus as the handful of European predecessors we have touched upon here. The fact of being American and Jewish—and the question of what those two words mean in the larger context of art—is what primarily unites them.

PART I

Immigrants and Artists:

Finding and Fixing a Place

City Life and Social Realism

Like most of their non-Jewish counterparts, Jewish immigrants to America at the beginning of the twentieth century sought refuge from various forms of oppression. Here they hoped to find—and many found—a wide-open land with endless possibilities that demanded only one thing of them: that they become Americans. The question of how to do that preoccupied them. The challenges of the still-raw, muscular new world before them were threaded with concerns derived from the world that they left behind, of revolutions, pogroms, the Dreyfus affair—and centuries of visual and other forms of Christian-based culture. To the question "What do I retain and what do I leave behind of the old world, in reshaping myself as part of my adopted country and culture?" the Jewish artist, then and since, adds: "Where does my art fit into the history of art that, for sixteen centuries, has been essentially Christian art?"

In the early twentieth century, the center of such questions (and answers) was New York City, which was in the process of becoming another Paris. Teeming with diversity, New York was a magnet for artists of all sorts, as it was evolving as a city where anything was conceivable, where old and new traditions alike could be habitually turned aside. The center of that center was the Lower East Side, whirling with energy and home to a handful of significant organizations that, by the turn of the century, were dedicated to molding (both Jewish and non-Jewish) immigrants into comfortable membership in American life.

Three organizations—the Hebrew Free School Association, the Young Men's Hebrew Association, and the Aguilar Free Library Society—merged in 1889 to integrate the "greenhorns" into America.[1] By 1893, the compendium was being called the Educational Alliance. In the course of the next decade, the Alliance offered an impressive array of programs, from a People's Synagogue with services in Hebrew and German to an orchestra offering quality Tuesday evening concerts (admission was 5 cents) and a Singing Society; from classes in musical instruction and theatre performances to a range of literary clubs; from summer camps and physical education classes to a Legal Aid Bureau. By 1895, the Alliance began its program of art classes, which both prepared students for the "uptown" art schools and sought to inculcate in them higher "standards of taste."

The idea that one should seek to uplift others drew on a particularly strong thread in the tapestry of Jewish thinking. From early rabbinic to later Jewish mystical thought, interpreters inspired by the Israelite prophets emphasized the obligation of *tikkun olam*—fixing the universe; actively improving the world into which we are born. The idea that this pertains to artists, articulated first by Pissarro, reached full efflorescence among New York–based artists in the first third

of the century.[2] The idea that art could be an instrument for moral uplift and also for raising the immigrant's consciousness to a "superior" American level of thinking yielded organizations besides the Alliance in which both Jews and non-Jews were active. The People's Art Guild sponsored a number of exhibitions in its brief heyday between 1915 and 1918. The Jewish Art Center focused primarily on promoting Yiddish culture, sponsoring exhibitions from 1925 to 1927; other groups emerged in the 1930s.

From shortly before the turn of the century to the 1930s, Jewish artists grappled with a variety of artistic influences from nativism to European modernism. As a group they were particularly inspired by the cityscape itself, with its alleyways and crowded street corners, its streetcars and hurried pedestrian masses. Among these artists were Leonard Baskin, Peter Blume, Philip Evergood, Aaron J. Goodelman, Chaim Gross, Minna Harkavy, Louis Lozowick, Louise Nevelson, Mark Rothko, Ben Shahn, the three Soyer brothers (Isaac, Moses, and Raphael), Abraham Walkowitz, Max Weber, Marguerite Thompson Zorach, and William Zorach. Some of them went to Europe for one or more years and brought European modernism back to New York. They were thus in the peculiar position of being immigrants seeking to become American while trying as artists to infuse American visual thinking with a consciousness of and interest in the new patterns emerging across the Atlantic.

Jacob Epstein and Chaim Gross

A few key artists from this circle were born in the United States, but left and never came back. Jacob Epstein (1880–1960) was born in New York City. He ultimately settled in London, where he accepted British citizenship in 1907 and established the foundations of world-class twentieth-century British sculpture. But his drawings in the first two years of the century, in New York, are part of the important visual record of the Lower East Side—a bubbling sea of humanity, punctuated by patriarchs and pickpockets—and significant for the idea that the artist must derive inspiration from the street life around him/her (fig. 11).

Chaim Gross (1904–1990), best known for his contribution to twentieth-century sculpture, also made a substantial mark as a watercolorist and lithographer.[3] Born in the Carpathian mountains of southeastern Europe, Gross was first a student of art in Budapest. He arrived in New York City in 1921 and left it thereafter only to summer in Provincetown. Gross was an artist who, in wrestling with his materials and his inspirational sources, evinced a consciousness of the dynamic tension between Jewish and American culture. Interviewed in his studio in autumn, 1984, he commented:

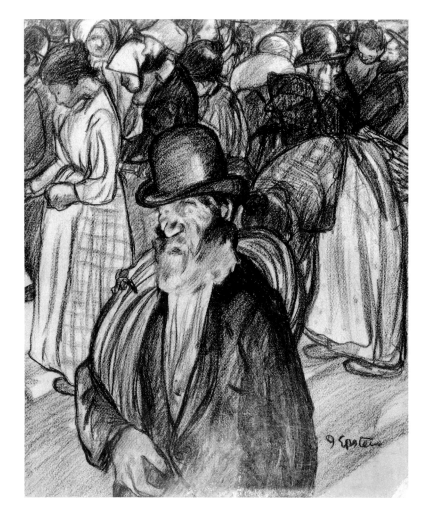

First of all, I would say that I am an *American* artist, because I am American; but I am *Jewish*, so I do a lot of Jewish subjects. But first I am an American; I am an *American* artist. I was born in the Carpathian Mountains, where the great Baal Shem-Tov [founder of the late phase of Jewish mysticism known as Hassidism] was also born. Later on . . . I was an immigrant to Budapest. During the war—this was 1916—you sit in the cafés, and you read the newspaper. One day, I picked up one of the magazines, and I just started to copy one of the pictures.

From that day on, I kept drawing and drawing . . .

. . . I had a brother, a great Yiddish poet, Naftali Gross. He used to say, "Chaim, your work is Yiddish [Jewish]. You can tell. The way you are doing your figures. They are Jewish girls." You can't get away [from that], because I am a Jew. And you cannot get away from it. You can't get away mentally or physically. And maybe, [even] if you try to get away from it, there is always something Jewish in your art. First, as I say, I am an American; I am an American artist. But I am also Jewish; as I am a Jew, so I do a lot of Jewish subjects. But first, as I say, I am an American. I am an American artist.[4]

That determination to be understood above all as an American artist had been articulated by many of Gross's older contemporary co-immigrants in the first few decades of the century. His work, covering a range of subjects, never included

anything like the volume of Epstein's early representations of life on the Lower East Side. For Jews, the center was already shifting uptown in the period between the wars when Gross arrived in America. Both the direct carving for which he became so renowned, and the drawings, watercolors, and lithographs that he produced until the month of his death, retain a consistently figurative lyricism, and in some cases an overt Jewish content, such as his focus on Jewish holidays (fig. 12).

Alfred Stieglitz

While Epstein was going to London and turning to vorticist modernism and Gross was depicting New York in a lyrical figurative manner, the photography of German-born Alfred Stieglitz (1865–1946) was offering one of the important visual records of the surging immigration to America of the era.[5] In *Steerage* (1907), the teeming masses of Eastern European immigrants (including Orthodox Jews wrapped in their prayer shawls, praying) are seen from the close but not *internal* perspective of the long-since-arrived (and not from Eastern Europe)

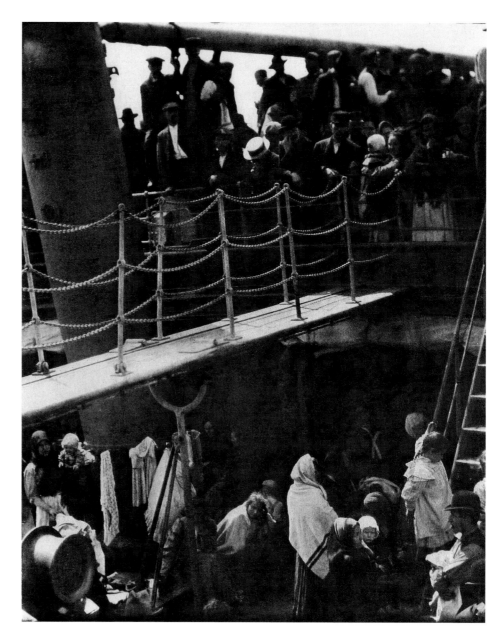

photographer (fig 13). This image has become an iconic visual reference point for discussions of immigration to America at the beginning of the century.

Stieglitz's skills as an editor, most particularly of the journal *Camera Work*, beginning in 1903, and as an organizer and patron, were of equal significance for the process of putting American art on the map. The establishment on Fifth Avenue of his gallery, "291," which between 1908 and 1913 was essential to introducing European modernism to America, contributed a steady stream of artists' work (both Jewish and non-Jewish) to exhibitions such as that offered by the People's Art Guild in May 1917 at the *Jewish Daily Forward* building. Stieglitz's ideology lay behind and led directly to the massive 1913 Armory Show, which placed cubists and pointilists, fauvists and impressionists, expressionists and symbolists before a largely shocked public that included former President Teddy Roosevelt and an avalanche of critics.[6]

Max Weber

Among Stieglitz's protégé-colleagues was Max Weber (1881–1961). Weber was born in Russia, the son of a religiously observant tailor. He arrived in Brooklyn at the age of ten. Weber's career would be multi-faceted, and his painting, which would be his primary occupation, variously sourced and developed. Like Jacob Epstein, he found acceptance (although not residence) in England first; like Epstein his most abiding artistic legacy is as an innovator in the works produced in the early part of his career. Indeed he would be the first American cubist painter of note. He analyzed the form of reality into its constituent geometries again and again, as in *Rush Hour, New York* (1915), where the city's energy is conveyed by intersecting lines and planes, curves, diagonals, verticals, horizontals (fig. 14). It is as if the viewer were watching the city rush by from within the rhythmic throb of a subway car—that expanding creature struggling to hold the expanding city together. But due to the abiding influence of Matisse and the fauves with whom he had worked in Paris for several years, he retained almost always a scintillating color palette and simultaneously the swirling sense of motion, speed, and skyscrapered height that are not only appropriate to depictions of the fast-growing city but suggest a relationship with the Italian futurists.

By the time of *Rush Hour, New York*, Weber had withdrawn (in 1911, not long after his one-man show at "291") from the Stieglitz circle and from the Armory Show (insulted at having been asked to submit only two works).[7] He was then, in a sense, outside both the central group of modernists and a public inhospitable to modernism. Weber's contradictory position is underscored by the fact that the cubist creations of his earlier years were largely mocked by American critics at that time, and even in 1930 when he became the first American artist honored with a retrospective at the Museum of Modern Art in New York, his modernist work of over a decade earlier was derided.[8] Nonetheless, the critics grew gradually more receptive, particularly to the more accessible figure studies—nudes— and overtly narrative Jewish subjects and landscapes that came to dominate his work in the course of the 1920s. These paintings seemed to share in responding to the imperative to define a non-Europe-influenced American art.[9]

By 1930, Weber had left the city and moved out to Long Island. His often phantasmagorical Jewish subjects turned him back to and drew from the memories of his Eastern European childhood (fig. 15). Earlier, as a theorist and writer about cubism and also as the author of cubist poems, he had emphasized the constant relationship between the material and the spiritual. The city contained a fourth-dimensional interior—its secular spiritual energy—that he had both discussed and sought to depict. His sense of the spiritual may also have impelled

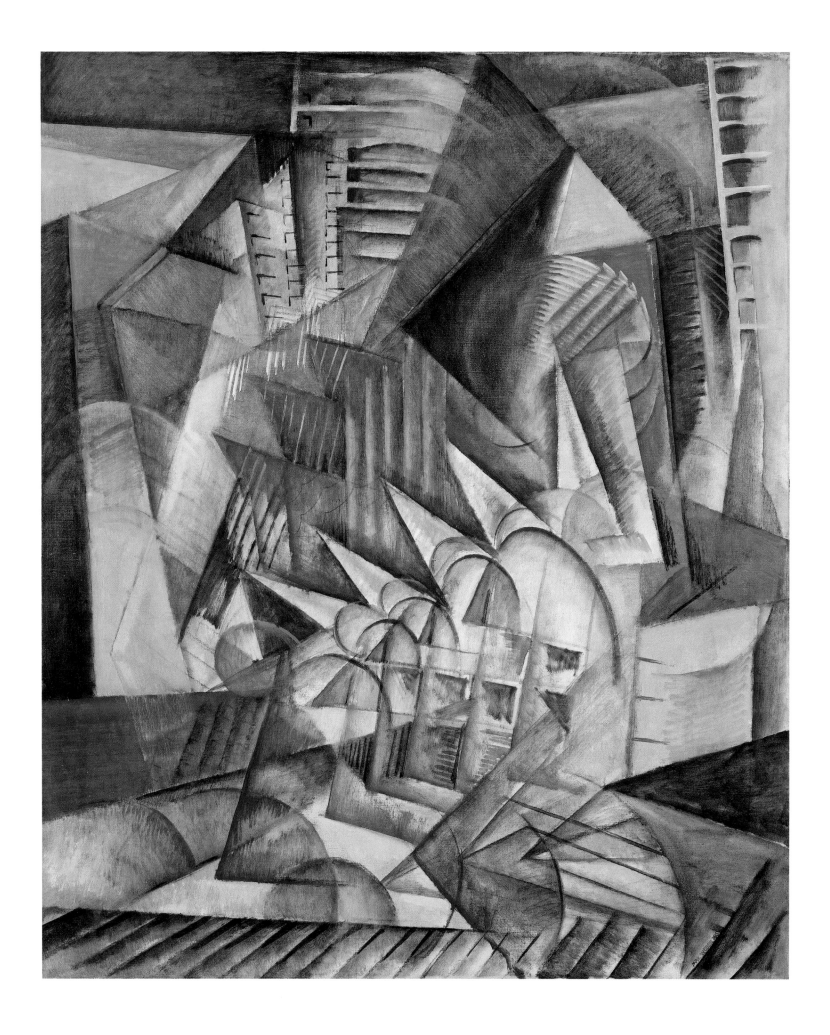

Fig. 15.

Max Weber, *Adoration of the Moon*, 1944. Oil on canvas. 48" x 32". Courtesy of the Whitney Museum of American Art. Photograph Copyright © 2001: Whitney Museum of American Art.

the personal interior direction that began to yield the Chagall-like visions of Old World–inspired Jewish life, even by the end of World War I, which became such a significant portion of his output by the end of the twenties.

Weber's turn to social realist themes in the thirties would find favor with critics. His *At the Mill* (1939) combines the fauvist coloration of much of his earlier work with its objectivist anonymity regarding the pathos inherent in the subject: meagre work and meagre earnings (fig. 16).

(Facing page) **Fig. 14.**

Max Weber, *Rush Hour, New York*, Gift of the Avalon Foundation, Photograph © 2001 Board of Trustees, National Gallery of Art, Washington, 1915, oil on canvas.

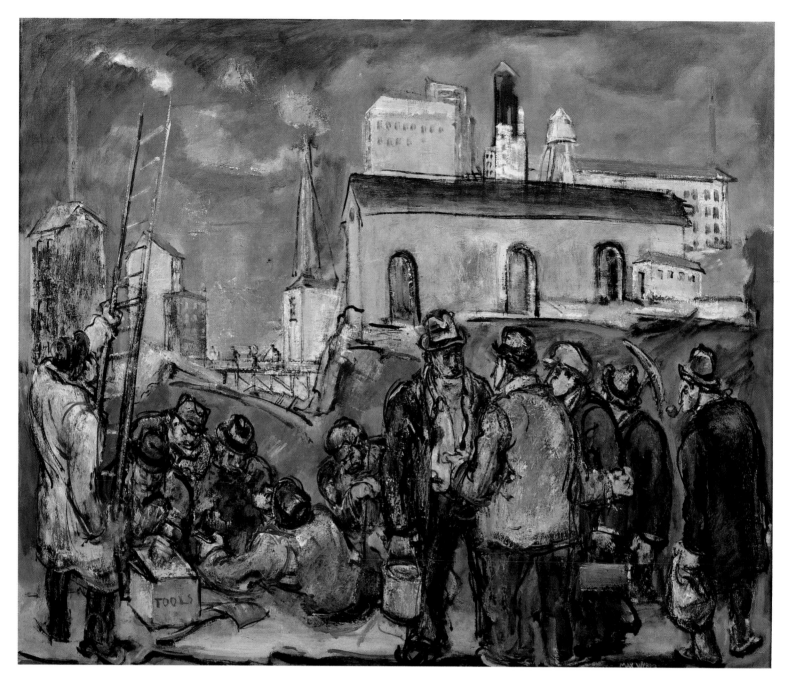

Fig. 16.

Max Weber, *At the Mill*, 1939. Oil on canvas. 40" x 48⅝". The Collection of the Newark Museum. Purchase 1946 Wallace M. Scudder Bequest Fund.

Some critics have seen a Jewish source not only for Weber's obviously Jewish narrative works, but in the searching eclecticism and in the Pissarro-like intellectuality of his art and his writings about art.[10] Certainly the cubist style with which he revealed and interpreted the internal geometries of the city is consistent with his 1916 dictum that "art is not mere representation. It is and should be, interpretation, revelation," as was his shift to the distinctively figurative style in which he revealed and interpreted the traditional life of his people.[11]

Abraham Walkowitz and Samuel Halpert

Among those influenced by Weber was Abraham Walkowitz (1878–1965), with whom he traveled to Italy in 1907 and with whom he briefly shared an apartment in New York in 1909. Walkowitz also came out of the Eastern European ghetto; he was actually born in Siberia, making his way to America, out to Europe (in 1906), and back to America. The visual fresh air that he imported back to New York included sensitivity to the naiveté of children's drawings. He sought to incorporate that innocence into his own images of bathers and city workers. While Weber may be regarded as the first major artist to import modernism to New York, it was actually Walkowitz who had the first one-man show of modernist work at the frame shop of his friend Julius Haas, in 1908. He helped Weber gain his first one-man show there the following year.

In much of Walkowitz's best work of that early period, a tangled cubistic geometricity, influenced by Weber's idea of the simultaneous multiple vantage point, echoes both the rhythms and the shapes of the city. Eventually it would yield to a more fluid, loosely handled curvilinearity, particularly as he grew more interested in portraying dancers such as Isadora Duncan. Similar yet not identical to Walkowitz's earlier style and subject matter is the work of Samuel Halpert (1883–1930). His *View of the Brooklyn Bridge* of 1915–1919, for example, rather than exhibiting the precisionist sensibility of Weber and Walkowitz's work at that same time, reflects the influence of the impressionists and the fauves, although by means of his own darkened palette (fig. 17). The bridge is a gigantic, almost sinister presence in this painting, dominating the cold river and even the cold sky and the buildings huddling, as if intimidated by it, on both sides of the river. Nature shrinks back before the constructive might of New York.

Louis Lozowick

A handful of other Jewish artists from the first quarter of the century offer varied forms of synthesis between the penchant for figurative depictions of the Old World–like street life of the city—in which the Jewish presence is obvious—and interest in the transformation of the cityscape into a powerful future-looking intellectual exercise. Louis Lozowick (1892–1973) is one of these synthesizers, as is evident in his 1925–1926 canvas, *New York*, with its almost black-and-white dialogue between light and shadow on the one hand, and rectilinear and curvilinear shapes on the other (fig. 18). The meeting and merging of such obviously male and female forms reflect his sense of paradox: the coexistence of the city's fecun-

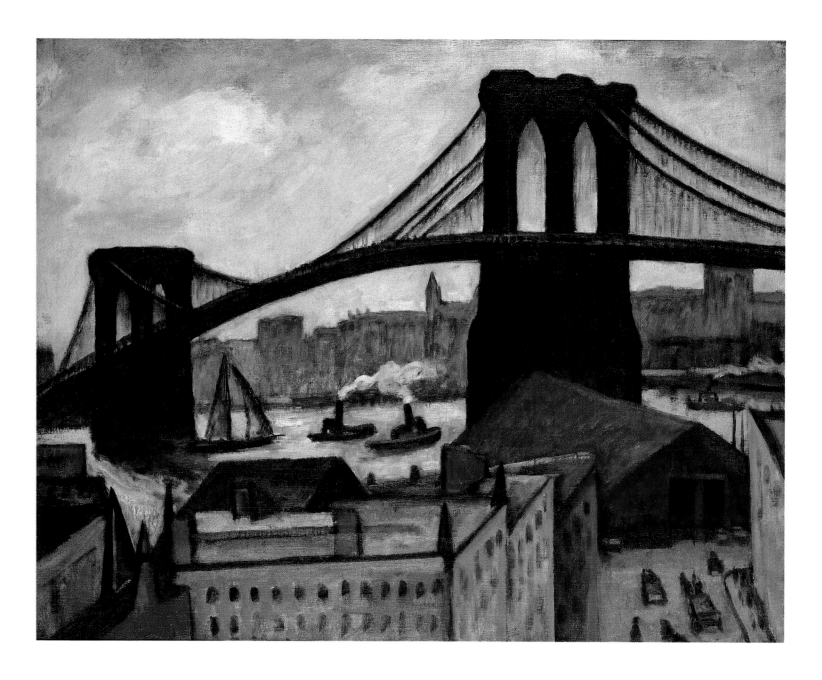

Fig. 17.

Samuel Halpert, American, 1884–
1930. *View of the Brooklyn Bridge*,
1915–1919. Oil on canvas.
72.3 x 91.6 (23½ x 36⅟₁₆). Brooklyn
Museum of Art. Gift of Benjamin
Halpert. 54.15

dity with its cold distance. It is a place vibrant with crowded life yet empty, anonymous, and still as death in its metropolitan enormity.

Lozowick was also a bridge between the national and international art scenes in his writing on Jewish art and his lecturing at the Art School of the Educational Alliance at the end of the teens. He lectured there again in 1924 and occasionally through the 1930s and 1940s. After his return to New York in 1924, his ideology broadened to include specific developments that he had witnessed during travels in Berlin and the new Soviet Union, such as constructivism. These perceptions were essential for deepening the aesthetic thinking of students at the Alliance. Lozowick also argued that the more firmly they understood and drew from their own tradition, feeling "[their] identity with the community of which [they are] a product by drawing inspiration from its life"—by which he meant identity with

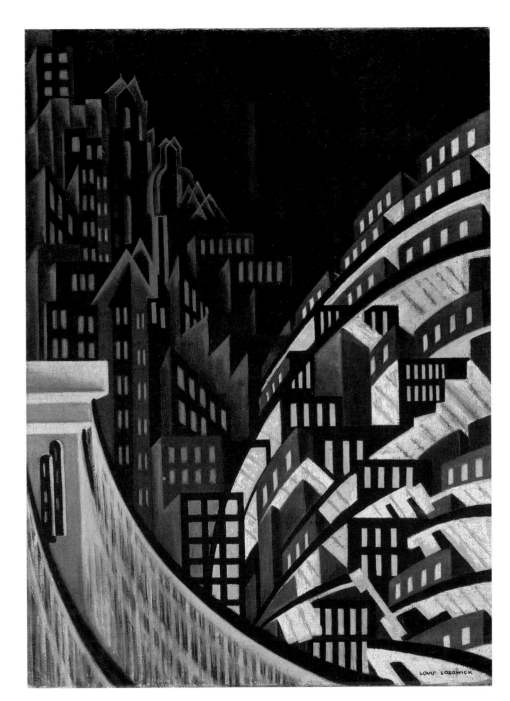

Fig. 18.

Louis Lozowick, *New York*, 1925–1926.
Oil on canvas. 30³⁄₁₆" x 22³⁄₁₆". Collec-
tion Walker Art Center, Minneapolis.
Gift of Hudson D. Walker, 1961.

the cultural and social rather than the ritual life of Jews—the more effectively
they would be able to contribute to the greatness taking shape as America.[12]

He was also implicitly arguing against those critics who denigrated the new
art and its non-native practitioners as un-American. In his writing in the 1920s,
Lozowick avoided mentioning the specific identities of Jewish artists whose work
he discussed, or the matter of Jewish identity and Jewish art. For him the ques-
tions of being a good or bad artist, and of good or bad art, were all that mattered.[13]
Unlike their African American counterparts, Jewish artists were rarely identified
by race or religion in reviews. Some critics, such as Mary Austin, attacked certain
"New York" critics—by which she meant Jews and "foreigners"—for presuming

to speak for America in the matter of artistic sensibilities.[14] But on the whole, by the 1930s American Jewish artists had arrived at a point where they could largely be *Americans*, and turn their talents to observing, commenting on, and even criticizing aspects of the American (and world) scene.[15]

In fact, by the 1920s and 1930s, the heightened *ethnic* consciousness of the immigrant artists was being supplanted in part by *class* consciousness. For a substantial number of American Jewish artists, left-wing organizations such as the John Reed clubs founded in 1929 and the Artist Union (1933) and American Artists' Congress (1936) reflected both their general—in part Jewishly inspired— social-political concerns and their realization that such memberships offered a path into a side-trickle of the mainstream. Social *consciousness* begat social *protest* in the context of the Depression. Artists expressing protest on canvas created the movement called social realism. Social, because the object of its overt commentary was society and its problems; realism, because a literal, figurative technique was employed.

The Soyer Brothers

Among the outstanding practitioners of social realism were the Soyer brothers: Isaac (1907–1981) and his twin older brothers Moses (1899–1974) and Raphael (1899–1987). They were all born in southern Russia. In 1912, their father brought the culturally hyperactive family to New York by way of Philadelphia. Isaac studied at Cooper Union and the National Academy of Design as well as the Beaux Arts Institute, but spent much of his time at the Educational Alliance where he began to teach, at age 19, taking the place of his brother Moses when the Alliance provided the latter with a two-year fellowship to go to Europe. Isaac was known mainly for depictions of the unemployed and the working class.

Moses and Raphael became part of that working class when they had to drop out of high school to help support the family. They were able to attend free evening art classes at Cooper Union and the National Academy of Design. Moses eventually attended classes at the Educational Alliance, where he met Louis Lozowick and his circle, and where eventually he would return to teach. Barnett Newman and Mark Rothko were among his students. His winsome portrayals of individuals were more often than not placed in interior settings, and offer a sensitive, sometimes delicately humorous mien. *The Lover of Books* (1934), for example, clings to and is flanked not merely by *books*, but by large *portfolio*-sized books—*art* books, then—as well as by sculptures, paintings and drawings: in short, all the densely organized trappings of a passion for visual culture (fig. 19). He has come in from the cold, perhaps to a library that offers his only refuge. He

Fig. 19.

Moses Soyer, *The Lover of Books*,
1934. Oil on canvas. 42 x 23½ in.
Courtesy of The Jewish Museum of
New York/Art Resource, N.Y. © Estate
of Moses Soyer/Licensed by VAGA,
New York, NY

appears somewhat unkempt, and wears a heavy, buttoned-up coat. His focus is on culture, not coiffure, and on us, whom he assesses with a gently piercing look. There is a specific touch of irony in where he is placed. To one side is a small sculpted figure, presumably of the Madonna, wrapped as he is—and yet so differently from how he his! To his other side a sculpted classical head sits at the level of and same size as his own head but elegantly inclined, its eyes closed in quiet ecstasy. Like him but so different from him: the book-lover's passion cannot carry him, at least at this wintry moment, away from the mundane as far as the close-eyed ecstasy of that classical head that is his alter ego.

Raphael Soyer stayed on full-time at the Academy until 1922, where he met, among others, Ben Shahn. During the twenties, he was involved, as Moses was, in the Yiddish-language literary group known as *Die Yunge* (The Young Ones), and frequented the Jewish Art Center where he met Abraham Walkowitz. This led to his acquaintance with the John Reed Club, where he met Louis Lozowick. By the 1930s, Soyer had arrived at his characteristic idiom, an anti-academic, flattened representation of the city scene and its inhabitants, a poetic sadness-evoking style that he never left behind. Wide, dark, empty-and-droopy-eyed countenance-shadowed self-portraits yield to the echoing depictions of others, such as his 1932 painting of *The Artist's Parents* (fig. 20). They stare inward, not outward, and are

Fig. 20.

Raphael Soyer, (b. 1899–1987). *The Artist's Parents*, 1932. Oil on canvas. H. 28 in. W. 30 in. The Metropolitan Museum of Art, Gift of the Artist, 1979. (1979.550) Photograph © 1980 The Metropolitan Museum of Art. © Estate of Raphael Soyer, courtesy of Forum Gallery, New York

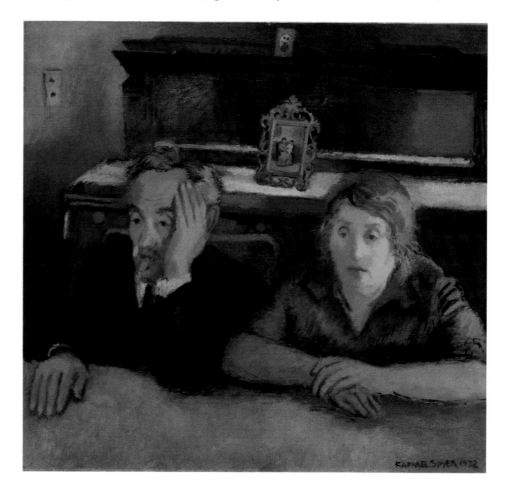

presented, compositionally, as part of and enclosed by a pyramid, that most stable of architectural forms, of their own making. For it is created by their arms across the horizontal of the table top, their shoulders and heads, and reaches its apex by means of the picture on the sideboard behind them. That picture is a black-and-white photograph, its precise subject vague, but it is clearly an old photograph of a mother and child. That is, it is an image of the past. This interior pyramid is held together by memory as it reaches its peak with that image from the past. Outside it fall the painful and stark elements of the present, including the ugly wall switch, which might easily have been left out by the artist. We ourselves, the viewers, stand outside that isolatingly inward pyramidal structure. We stare at them but they don't even acknowledge our presence with their looks; they barely notice each other. But that is from years of habituation to each other, not from denial of what lies outside their bleak triangle of loneliness, us included.

The work is a powerful statement of how the older generation suffers the pains of the immigrant condition. If the young can generally embrace the new world of America eagerly, the old often characteristically remain emotionally and mentally attached to the world they left behind. With all of its problems, the Old World offered the comfort of familiarity. The New World, with its own language, culture, and customs, offers shock and conflict. We see the artist's parents self-isolated, caught between the Old World and the New, their bodies here and their minds there.

Isolation—not existential *angst*, as much as *aloneness*—is a recurrent motif of Raphael Soyer's work. That mood is also found in his later *City Children* (1952), which recalls in his presentation of a series of figures across the front of the picture plane as links in a chain the compositional lack of depth in the *Deposition* by the seventeenth-century Flemish painter Rogier Van der Weyden (figs. 21 and 22).[16] Soyer's chain, however, is composed of *unconnected* links: no figure actually touches any other; each is enveloped in his own world. The sudden blotch of red reinforces, within and without its ground colors, the sense of isolation. And these are not cynical, long-lived adults, but mere children! Sadness oozes out of them for the everyday difficulties of their underclass lives, in contrast to the Christ-focused, and thus somehow uplifting even if mourning, mood of Van der Weyden's work.

One of the elements that perhaps feeds into Soyer's isolationalist sensitivity is his experience not only as an immigrant, but as a Jew, however assimilated. While he and his family are surely emblematic of the immigrant generation at large, lost at times in the vast sea of a new culture, they were forced into emigration from Russia in the specific context of the Beiliss Blood Libel trial—in which the survival of a medievalist Jew-fear and hatred into the twentieth century was a central

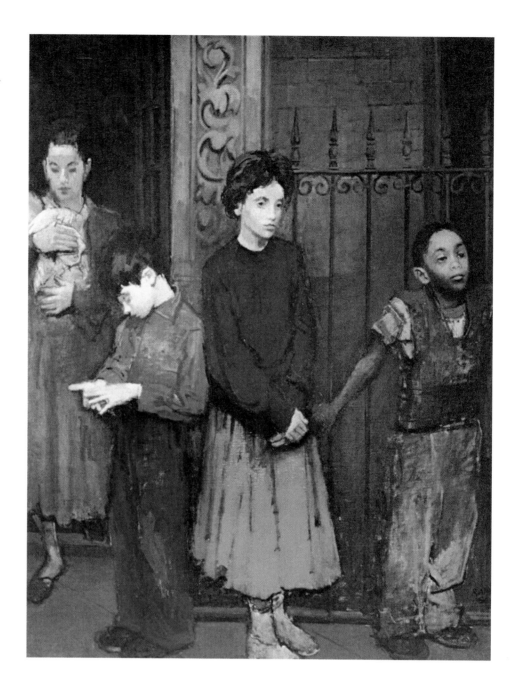

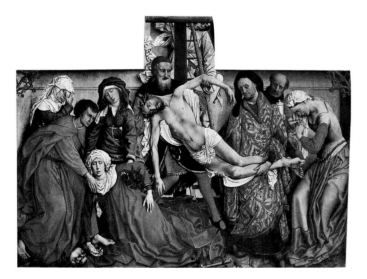

element.[17] So perhaps his specific *Jewish* emigrant trauma, carried to these shores with a never-healed sense of separateness, was still retained in the paintbrush and sketching pencil forty years (and one can observe it a full seventy years) later.

Ben Shahn

The Beiliss trial had symbolized for some the acute need for a socialist revolution in Russia to bring equal status to all, including Jews. The Jewish emphasis on *tikkun olam*—repairing the world; leaving it a better place than it was when one was born into it—had, for many, taken a secular turn with the development of Socialism: it seemed to offer a means of *tikkun*. Initial hope in Socialism's possibilities and later disappointment over its failure and the failure of social liberation movements generally is particularly pronounced in the work of Ben Shahn (1898–1971), one of the key practitioners of *tikkun olam* on the canvas by the 1930s. Born in Lithuania, Shahn arrived in Brooklyn in 1906. His father was a woodcarver and an active socialist. The son became one of the best-known protest painters in America. "I hate injustice," he wrote at the time, "I guess it's about the only thing I really do hate."[18]

If Soyer's art may be defined by aloneness, Shahn's may be defined by anger controlled by a strong sense of irony, a feature that defines much of the Jewish historical experience.[19] Shahn often referred to this sensibility in describing the extremity of his social consciousness. His style—nervous, skipping lines and an extreme, poster-like flattening of perspective—owes a debt to Paul Klee, as he focuses on detailed moments from scenes larger than the canvas borders. His substantial swatches of pigment filling out eloquently simplified forms, also connects him to the early Italian Renaissance genius, Giotto. So, too, the sense of his work as encompassing large issues, together with his interest in political-social matters, derives in part from the two years between 1932 and 1934 that he spent as an assistant to the great Mexican muralist Diego Rivera in the hugely controversial Rockefeller Center fresco project.[20]

By then Shahn had already had an exhibition at the Whitney Museum of American Art (1932) and had begun to tackle substantive subjects. Miscarriages of justice were already a passion that he was expressing visually, from a series done in 1930 on the Dreyfus Affair, to one focused on the case of Sacco and Vanzetti in 1931 to 1932. "Ever since I could remember I'd wished that I'd been lucky enough to be alive at a great time—when something big was going on, like the Crucifixion. And suddenly I realized that I was! Here I was living through another crucifixion. Here was something to paint!" he would write.[21] *The Passion of Sacco and Vanzetti* offers the distorted expressionistic faces of the Lowell Committee,

bigoted New England blue-bloods, leaders, among others, from Harvard University and M.I.T., whose job it was to assure that no bias was expressed in the trial of the two anarchist Italian Americans (fig. 23). In Shahn's painting they bear, as hypocritical mourners, flowers of innocence—the white lily so often placed in the Angel Gabriel's hand by Renaissance portrayers of the *Annunciation* to the innocent Virgin Mary of her divine pregnancy.

The lily is also the symbol of death and resurrection, and the blood-red that fringes it in Shahn's painting underscores the bearers' blood-guilt. The flutes of the columns on what is apparently a courthouse appear almost as bars, as the bigoted judge—justice itself incarnate—who found Sacco and Vanzetti guilty and organized their execution, is inescapably framed, imprisoned within the grandiose architecture that is justice's emblem.

Differently, in his 1939 *WPA Sunday*, the artist, himself a WPA painter during the Depression, observes with a steady eye the jobless, churchless, and homeless waiting for the uplift of WPA programs. But Shahn's social concerns carry from America abroad and from social and political injustices to war. His *Italian Landscape* of 1943 to 1944 reverberates with martial devastation (fig. 24). The moment portrayed is death. It is distinctly—and that's the point—man-made death, *war* death, suggested by the bombed-out Roman aqueduct-like bridge, which offers the idea of the transgenerational continuum of human civilization: We both build and destroy. From old woman to small child, life like death goes on. Moreover, the multiple echoes of the Trinity—three arches, three black-clothed foreground presences, three more echoing these in the background—offer no hope of divine intervention against ourselves.

For Shahn as a Jew, God does not become Man to redeem humankind from our sinful errors. Redemption from war or joblessness can come only through human effort. A sense of existential aloneness is particularly evident in the artist's 1946 *East 12th Street*—center of the center of the New York School that dominated American painting in the 1930s and 1940s—which has been rendered as a canyon of Albertian Italian Renaissance perspective gone awry (fig. 25).[22] Children hurtle toward an empty infinity, watched by expressionless identical building fronts. Only with a third or fourth look do we realize that they are merely children (like Soyer's city children) roller-skating. The whole is clothed in reds and blacks, which, for Shahn as a student of Italian Renaissance symbolism, are the colors of Purgatory.[23] We are led visually from the foreground hell, which begins off the canvas and must include us, the viewers, in our post-war reality, toward a questionable haven at the painting's interior—its distorted vanishing point.

Although some of Shahn's works are overtly Jewish, most of these appear later in his career.[24] In his 1968 "Identity," five pairs of clenched fists are raised like

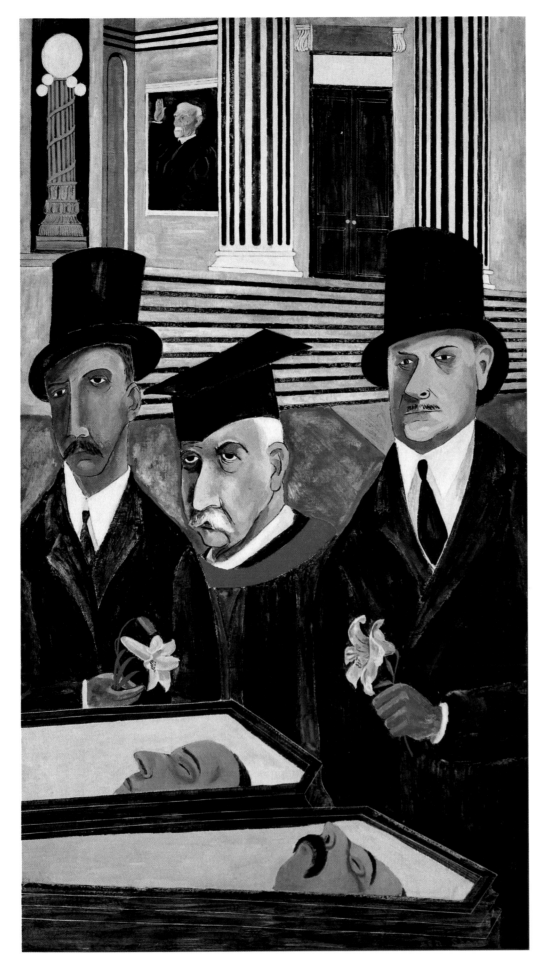

Fig. 23.

Ben Shahn, *The Passion of Sacco and Vanzetti* (1931–1932) from the *Sacco-Vanzetti* series, Tempera on canvas. 84½ x 48 in. Collection of Whitney Museum of American Art, Gift of Edith and Milton Lowenthal in memory of Juliana Force. Photograph Copyright © 2001: Whitney Museum of American Art. © Estate of Ben Shahn/Licensed by VAGA, New York, NY

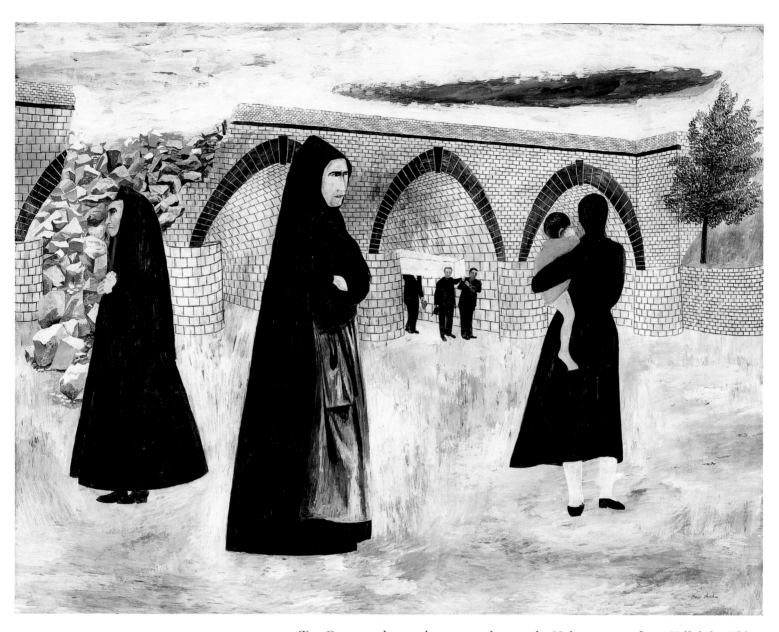

Ten Commandments heavenward, toward a Hebrew quote from Hillel the Elder:
"If I am not for myself, who will be for me? But if I am only for myself, what
am I?"—words perceived by Shahn as a statement of his *own* identity, as individ-
ual, family man, member of a community and citizen of the United States, Jew
and member of the human race. Indeed this work succinctly defines the artist:
as an individual and a member of humanity. A key bridge between those two
identities is formed by the Hebrew words spoken two millennia ago by the most
significant humanistic Jewish thinker of his time.

Precisionism, Magic Realism, and Political Commentary

If the language of social realism in the 1930s is as mundanely down-to-earth as the
graphic tradition of magazine illustration and poster art, the art of the magic real-

Fig. 25.

Ben Shahn, *East 12th Street*, 1946.
Tempera on paper. 22" x 30". © Estate
of Ben Shahn/Licensed by VAGA, New
York, NY

ists expressed the realities of the 1930s—joblessness, poverty, the threat of coming war in Europe—by combining the factual with the fantastic. But Ivan Albright, Paul Cadmus, Louis Guglielmi, Henry Koerner, Alton Pickins, and, among the Jewish painters, Peter Blume, chose rarely the monstrous images that are often part of surrealism. Rather, in photographic detail, they turned upside-down the everyday images of the American scene.

Peter Blume

Peter Blume (b. 1906) has been called the most sophisticated of the practitioners of magic realism.[25] Born in Russia, he arrived at the age of five in Brooklyn, where his art studies began with evening classes, followed by classes at the Alliance in the early 1920s. There he met the Soyer brothers and Chaim Gross and cultivated what has been called the precisionist style, based on its goal of technical brilliance associated with and inspired by the early Flemish masters. By adding to that sensibility a certain surreal quality of subject matter, he engineered magic realism into existence by the end of the decade. In his 1931 *South of Scranton*, there is a matter-of-factness to the surreal images; the juxtaposition of human and natural landscape with a somewhat semi-circular progression of naked human figures leaping onto the deck of a docked boat—but really from nowhere to nowhere on a structure that appears to be a diving platform combined with a battleship crow's nest. Juxtaposed with images of strip mining, it offers a commentary on human survival in the midst of chaos and destruction (fig. 26). The work earned Blume

first prize at the Carnegie International Exhibition; he was the youngest painter
ever to be so honored.

The style that *South of Scranton* exemplifies has also been labeled social sur-
realism. Blume would write: "Since I am concerned with the communication of
ideas, I am not at all ashamed of 'telling stories' in my paintings, because I con-
sider this to be one of the primary functions of the plastic arts . . ."[26] — leaving to
us the matter of interpreting the stories he tells. In *The Eternal City* (1934–1937),
Rome has been distilled and distorted (fig. 27). The columns of crumbling ruins
in the partially excavated ancient forum are there, as are rocks that recall the
background of Leonardo da Vinci's *Virgin of the Rocks* and a variety of out-of-
context images: above all the leaping-necked bright blue jack-in-the-box. It is
a caricatured scowling Mussolini, whose Rome Blume had visited while it was
being fascistically transformed, and it dominates the foreground in its past and

present mis-mix of elements. A contemporary couple is almost lost in the un-earthing of the glorious imperial past, as they look up in alarm at the gigantic vis-age towering over them. Seriousness engages playfulness, magic engages a reality as surreal as it is all too real.

William Gropper

In the 1930s, characters like Father Coughlin were emulating the facial contor-tions and fascist sentiments of Mussolini and Hitler on American radio. The need to respond to the world in visual terms was being felt, particularly by Jewish artists, with increasing urgency. By then, too, *American*-born Jews were beginning to make an impact on the visual scene in New York. William Gropper (1897–1977) was born on the Lower East Side. He attended both pubic school and a traditional Jewish school (*heder*), as well as studying art at the Ferrer center, where the medium was discussed by luminaries such as Robert Henri and George Bellows,

and at the National Academy of Design and the New York School of Fine and Applied Art. By 1917, he was working as a cartoonist/illustrator for the New York *Tribune*.

Gropper's work was inspired by the pungent style and incisive line of Daumier and the mordant tone of Georg Grosz. He contributed art to most of the leftist publications, Jewish and non-Jewish, published in English or in Yiddish, of the twenties and thirties. By 1936, his first major exhibition was held at the ACA Galleries in New York; the following year a Guggenheim Fellowship led to a series of paintings on the Dust Bowl. These paintings offer an important documentary of impoverished rural America. WPA-supported paintings, like *The Isolationist*, with its striking portrayal of a proto-fascist U.S. Senator, were a logical prelude to his turn to anti-Nazi imagery in the early forties. *Hostages* (1942) is typical of Gropper's combination of muted earth tones and almost caricatured figures; the reverberation back and forth between the angles of background landscape elements and those of the foreground figures—legs, arms, and rifles playing against the thrusting diagonals, the light and shadow of the rocks—yields a dynamic composition (fig. 28). There is also a cold metaphorical horror to the juxtaposition of forms: human jealousy, hatred, and cruelty, of which war is the leading expression, are old and extremely slow to change, like the rocks.

Fig. 28.

William Gropper, *Hostages*, 1942. Oil on canvas. 21 x 32⅛". The Collection of The Newark Museum, Purchase 1944 Sophronia Anderson Bequest Fund.

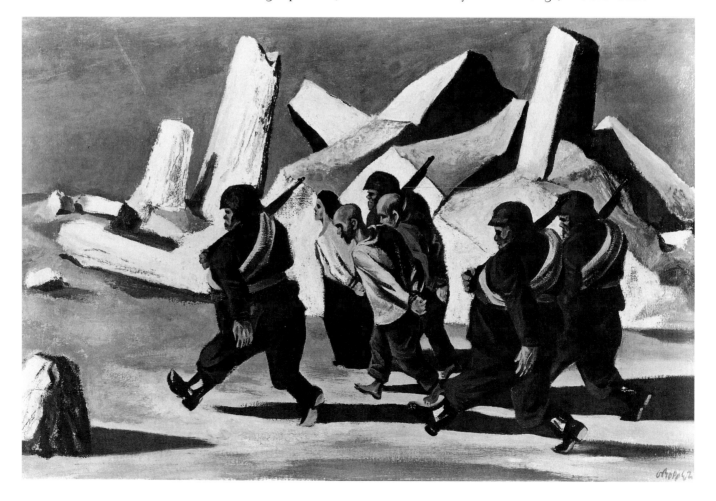

Hyman Bloom and Jack Levine

By the 1940s, Hyman Bloom and Jack Levine, "two kids from Boston," were creating important figurative painting and visual commentary. Bloom painted phantasmagorical visions threaded to magic realism and to the work of Chaim Soutine—writhing and melting, other-worldly, in brilliant, visceral colors. His various paintings that focus on ritual and architectural elements in the synagogue demonstrate this as it also reminds us of the interest that numerous Jewish painters of this era had in overtly Jewish subject matter. But it is Bloom's fellow Bostonian, Jack Levine, who eventually made his way to New York and became the dominant New England–born Jewish painter, and one of the pre-eminent socio-political painters produced by America in this century.

Levine's very this-worldly social realism–like subjects of corrupt and crass capitalists scintillate with a style that weds a particular magic—of pigment and light, not of Blumian subject—to that realism. Born in Boston in 1915, the artist "took my place in the late 1930s as part of the general uprising of social consciousness in art and literature . . . We were all making a point . . . We had a feeling of confidence about our ability to do something about the world."[27] Like Shahn's, his sense of *tikkun olam* was profound, secular, and powerfully articulated on the canvas. The broad spectrum of the American experience quickly became Levine's subject; his stylistic trademark is the play on his canvases between focused image and distorting indistinctness, particularly as his tendency toward satire becomes more pronounced.

Then twenty-two, Levine leaped onto the New York and national scene as both a sharp, stinging commentator and a brilliant technician with his 1937 painting, *The Feast of Pure Reason* (fig. 29). The trinity of people-protecting public servants—policemen and politicians—are overstuffed, glistening beings, leeches fattened on the blood of the people they have forgotten how to serve. The title is drawn from a moment in James Joyce's *Ulysses* when the hero has been knocked down by two constables and lost his glasses and walking stick. To the passerby who hands him his stick, he comments "What need have I of a stick in this feast of pure reason?" The irony that the supremely unreasonable moment through which the hero is moving has been perpetrated by the police is enhanced by Levine's style. The canvas shimmers as if a silken veil were placed across it, with lights playing through it, as if we can't quite *see* it.

That style is Levine's life-long signature. We see it in his early 1950s *Gangster's Funeral*, which also offers a related social comment. The chief of police, the mayor, the governor are all at the funeral, and can hardly be distinguished from the gangsters. The pious reverence of everyone present—no doubt at least one

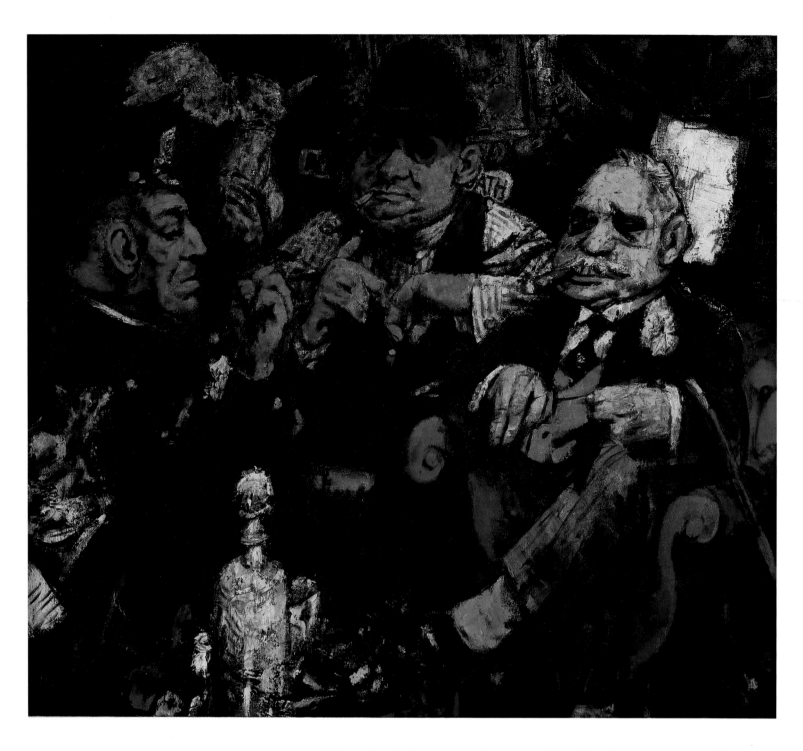

Fig. 29.

Levine, Jack. *The Feast of Pure Reason*. (1937) Oil on canvas, 42 x 48" (106.7 x 121.9 cm). Extended loan from the United States WPA Art Program to the Museum of Modern Art, New York. Photograph © 2001 The Museum of Modern Art, New York. © Jack Levine/Licensed by VAGA, New York, NY

of them the dead man's murderer—is offered by their mourners' clothing but missing from their obviously empty hearts. Similar implied questions about our species oozes from his later (1964) *Judgment of Paris*. The Trojan prince Paris who must judge the most beautiful among three goddesses is his ostensive subject. In Greek mytho-history, that choice would ultimately lead to the destruction of Troy and the deaths of Trojan and Greek heroes alike. The issues are eternal, but this is not Paris or Troy. It's only a be-shaded city guy ogling three women with knowledge, panache, and sex to offer as bribes in exchange for his beauty vote. In the background, the architectural symbol of classical culture and religion, a

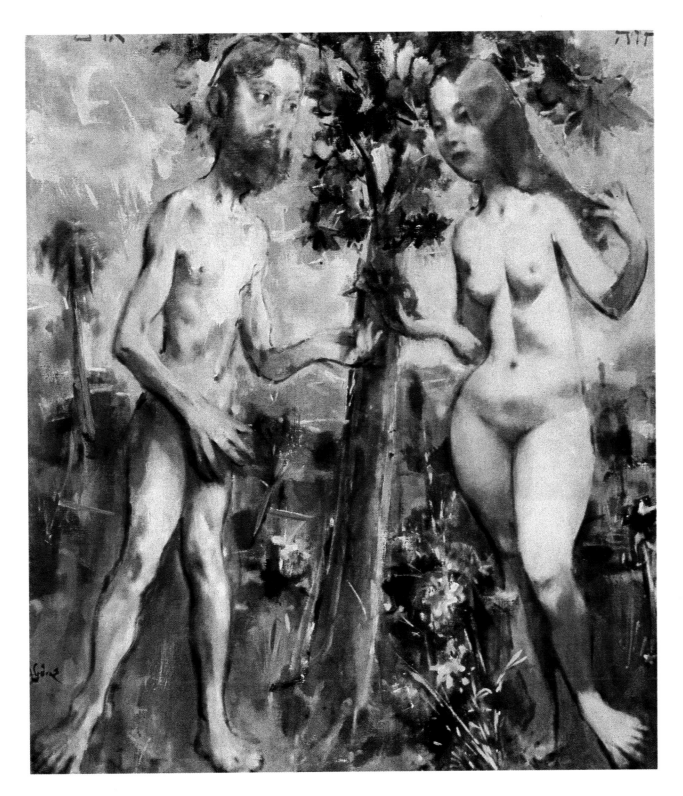

temple edifice, has been reduced to a museum, its doric austerity dwarfed by a Coca-Cola advertisement.

While this painting actually carries us into the 1960s, its tone is consonant with works from Levine's first fame of the 1930s and 1940s, a number of which derive their inspiration from the Bible. *King David*, from 1941, for example, is a brooding headstrong figure who, like his secular counterparts in Levine's painting, is noteworthy for an enlarged caricature-like head, in whom the disappoint-

Fig. 31.

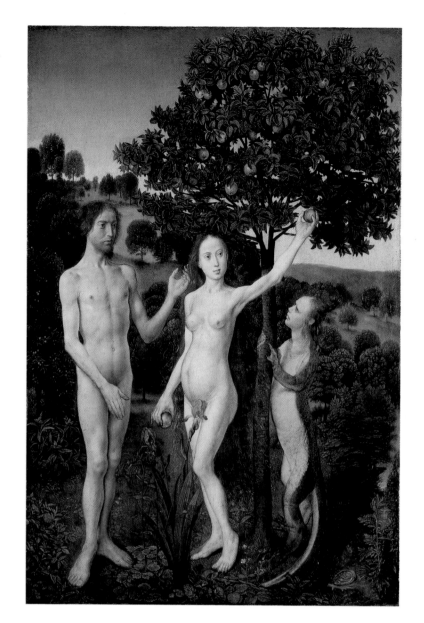

ments and responsibilities of the Israelite king, not his triumphs, are uppermost. This reversal of the "norm" is even more apparent in his *Adam and Eve* of 1959 (fig. 30). This work is strikingly related to a painting by Hugo Van der Goes, the fifteenth-century Flemish artist (fig. 31). Van der Goes' image reflects a familiar Christian perspective, in which the serpent prior to the "Fall" stands as we do, with a humanoid face. The devil incarnate, he is placed on the opposite side of the tree from Adam and Eve. Levine has entirely eliminated that figure. He has placed Adam and Eve flanking the Tree of Knowledge, has transferred the curved legs of the serpent, terminating in large webbed feet, to the human figures themselves: the serpent is within us; we are responsible for our own destinies. In this particular case—but it is the artist's repeated theme—we are responsible for our own falls, for the debasements we enact in the world around us.

PART II

Between Representation

and Abstraction

The Ten and Others

With the rise of fascism in the 1930s, the sources for political as well as socio-economic commentary for American Jewish artists and their colleagues expanded. One group of nine artists—coincidentally or not, all of them Jews: Ben-Zion, Ilya Bolotowsky, Adolph Gottlieb, Louis Harris, Jack Kufeld, Marcus Rothkowitz (Mark Rothko), Louis Schanker, Joseph Solman, and Nahum Tschacbasov—formed their own exhibiting group in early 1936, and called themselves "The Ten" (leaving always one spot open for a "guest" artist). Their most common concern for the roughly four years that they exhibited together was an aesthetic one, the formal structure of the canvas. Socio-politics was, in theory, outside their sphere of interest—some have argued that their intention was to divorce art from politics[1]—and religious issues were of varying interest to them. But during that period, socio-political messages seem more often than not to be no further than just beneath the surface.

Ben-Zion

Among The Ten, Ben-Zion (1897–1987) offered the most overt Jewish connections. He had begun his artistic life, in fact, as a Hebrew-language poet. Born in Poland as Ben-Zion Weinman (he eliminated the last name shortly after coming to America), he came as a published playwright to the United States in 1921 and quickly became involved in Zionist-Hebraist circles, continuing to write rather prolifically through the 1920s. But by the mid-thirties he began to feel his words drying up, not in the sense that he was uninspired, but that, in the face of the Stalinist and Hitlerian horrors already taking shape in Europe, words were a sacrilege. He took up the visual arts in part as a means of expressing his frustration at what was happening to humans due to other humans.

Ben-Zion's is a vigorous expressionist style. Thickly layered, textural sweeps of field and earth and sky recalling the landscapes of his youth—or, with different conceptual underpinnings, those of his adopted land—and powerful "portraits" of animals that boldly confront the viewer from the canvas filled his studio (fig. 32). Over the next decades he produced portrait after portrait, most of them without specific names—in all media, from found-objects sculptures to ink drawings done with sticks, rather than pens or brushes—recalling the faces of the Jews among whom he was brought up in the communities throughout Ukraine where his father served as hazzan (cantor). From the shamash (beadle) of his father's shul (synagogue) in Tarnov to obscure scholars, from potters and carpenters to idlers, an endless array of faces form part of what had become a memorial to the dead

Fig. 32.

Ben-Zion, *Crucifixion of the Road*, 1935. Oil on canvas. 24" x 30". Estate of Ben-Zion, Photographed by Roman Szechter.

by the late forties. Faces and figures alike are depicted with thick dark outlines, as if the lines of Paul Klee and Ben Shahn have been merged with those of Rouault.

Ben-Zion fashioned an entire agglomeration of faces, like piles of pebbles washed up on the beach in paintings and a lithographic series of 1943, *de Profundis (Out of the Depths): In Memory of the Massacred Jews of Nazi Europe* (fig. 33).[2] Eloquent Giottesque patriarchal heads, framed by prayer shawls, tilt and turn like boulders crowded into a pit—or like gravestones tilted and turned in a centuries-old cemetery, or like the pebbles left, in the Jewish tradition, on gravestones before one leaves a cemetery to signify having been there—for "I could not restrain a personal expression of grief" at what was transpiring in Europe.[3]

Ben-Zion was by no means limited to visual outbursts reflecting on fascism and the Holocaust, although this was his starting point as a visual artist. He

plumbed the depths of biblical texts from the story of Adam to that of Tamar. He
responded with equal fascination to the literatures of Mesopotamia and Greece,
from Gilgamesh to Oedipus; the artist who left the word behind looked again and
again to texts for inspiration. He explored the spiritual life and the rituals and cel-
ebrations of his people, from the blessing of the wine on the Sabbath to the
dwelling in a succah (booth) during the fall harvest festival. Countless images of
prophets dream as the stars and moon float down, gigantic, to earth; scribes, glow-
ing with a golden aura, carefully prepare the sacred double scroll of the Torah.
Myriad images of Moses, in diverse media, intermediate between heaven and
earth, and a series of paintings of the Baal Shem Tov, founder of Hassidism, bare-
foot and bearded, his blank blue eyes bespeaking an inner vision blind to
the sweep into modernity of our world, poured from Ben-Zion over the decades
(fig. 34).[4]

Nahum Tschacbasov

If Ben-Zion was the artist among The Ten who reached most fully and consistently into the specifics of the Jewish past and, in the late 1930s and early 1940s, the specifically horrific picture of its European present, others, in varying degrees, turned the world toward the canvas, in spite of the notion that their work should be divorced from the socio-political commentaries associated with social realism. Nahum Tschacbasov (1899–1984) was born in Baku, Azerbaijan, and arrived in Chicago at the age of eight. He lived in New York, Chicago, and Paris between 1926 and his final settling in New York in 1934. In Tschacbasov's 1936 *Deportation* he has framed the scores of skeletal-faced and ghost-bodied deportees within grinning rows of fence pickets and the sharp-angled chaos of blank-windowed house walls and roofs (fig. 35). This was one of a series of works recording the specifics of a world which, since the end of the Great War, had been overrun with displaced persons and unwelcome populations, from the closed door policies of the United States by 1924 to the massive removals to Siberia in Stalin's Soviet Union after 1934 to the trains shuttling between various parts of Europe and the concentration and extermination camps located in Poland after 1941.

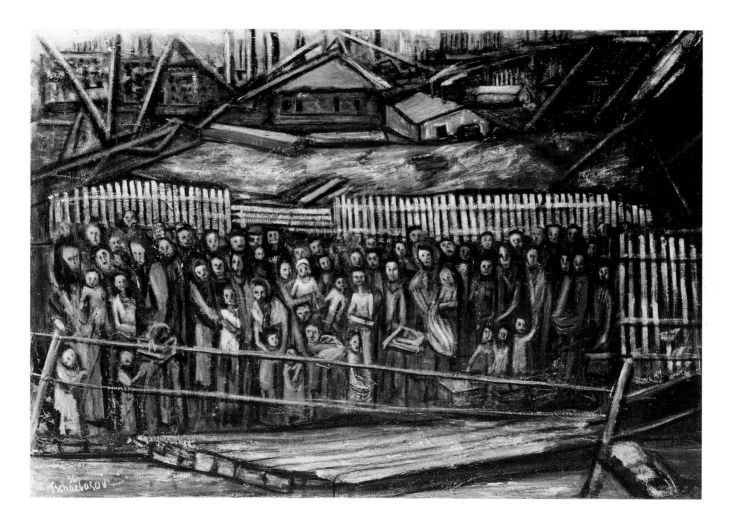

Ilya Bolotowsky and Joseph Solman

Ilya Bolotowsky (1907–1981), born in St. Petersburg, Russia, and an immigrant, by way of Istanbul, to New York by 1923, began experimenting with abstract painting by 1934. He also produced narrative works that reflected the activities of the everyday people around him. One sees this in his WPA murals and oil paintings like *In the Barber Shop* (1934), where a particular slice of American life—connecting, as part of a continuum, the small towns of the nineteenth century to the big cities of the twentieth century—is handsomely preserved (fig. 36). Joseph Solman was born in Chagall's hometown of Vitebsk in 1909, and at the age of three was brought to New York. The only surviving member of The Ten today, he perhaps came closest at that time to eliminating the idea of socio-political observation from his representational paintings, since he usually didn't include human figures. However, if the dark nooks and crannies of his Lower East Side are devoid of people, they are not devoid of mood and thus of implied social commentary. One might say that Hopper's eloquent New England facades, with their dark windows and strong contrasts of light and shadow, have been translated into the New York context of *The Coal Bin* (1937), and of street corners and shop fronts (fig. 37). Swatches of wall and fence, corners and crevices, and occasional signs exude loneliness and a sense of metaphorical abandonment: Where, these paintings seem to ask, has humanity gone? If that is an eternal existential question, it is one with a particular edge in the depression- and fascism-scarred context of the 1930s.

Adolph Gottlieb and Mark Rothko

From among The Ten, Gottlieb and Rothko would be, by the mid-forties, among the leaders of a new abstract movement, and as such their work would be assumed by most viewers to be absolutely divorced from the world beyond the canvas frame. Yet both artists were still substantially engaged in figurative art in the thirties, both before and as part of The Ten, creating images that as often as not suggest narrative commentary. Gottlieb (1903–1974) was born in New York City, the son of prosperous immigrants from Germany. By the time he met Rothko in 1928 he had studied at half a dozen art schools in New York and Paris and met many of the key figures of the present and future New York art scene, including Robert Henri, John Sloan, John Graham, the Soyers, Ben Shahn, Chaim Gross, and Barnett Newman. Rothko (1903–1970) was born in 1903 in Dvinsk, Russia; he arrived in America at the age of ten. He certainly would have had strong personal memories, both long-term and recent, of antisemitism, from the pogroms in his

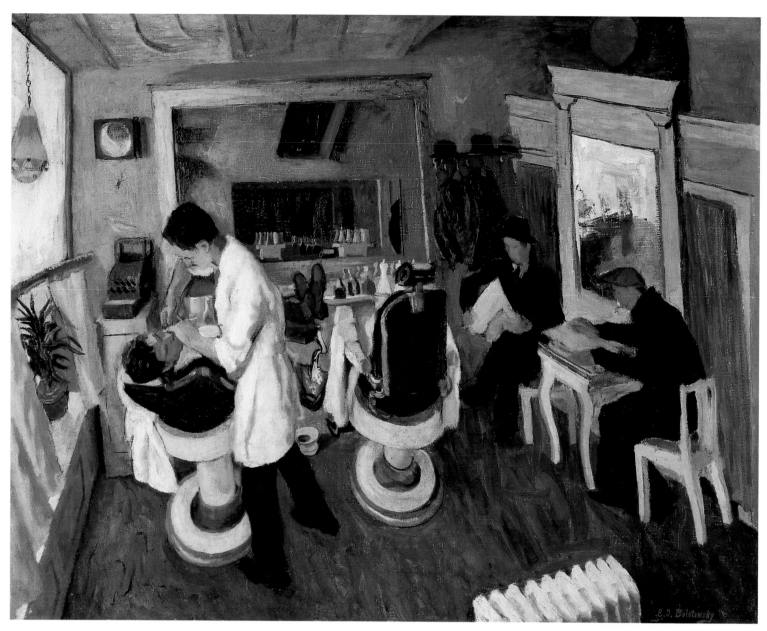

Fig. 36.

Ilya Bolotowsky (1907–1981). *In the Barber Shop*, 1934. Smithsonian American Art Museum, Washington, DC/Art Resource, NY. © Estate of Ilya Bolotowsky/Licensed by VAGA, New York, NY

childhood town to the more genteel anti-Jewishness that he experienced at Yale, where he was a scholarship student between 1921 and 1923. Both artists made repeated use of the image of the Crucifixion during the mid-thirties, and tended to include, as a visual element, the kind of dark double stripe on the loin cloth of Christ that suggests a *tallit* (Jewish prayer shawl), which underscores the re-vision of Jesus as a symbol of suffering Jewry, rather than the self-sacrificing savior of humankind that is the traditional understanding of his significance.

There is a double irony in this. First, each of these artists, by virtue of being part of The Ten, is generally understood to have responded to the parochialism of American regionalism with universality and to the intensity of socio-political commentary of social realism with non-political art. But they created an immense body of work that *is* political, and that offers echoes pointedly time-and-space specific and universal.

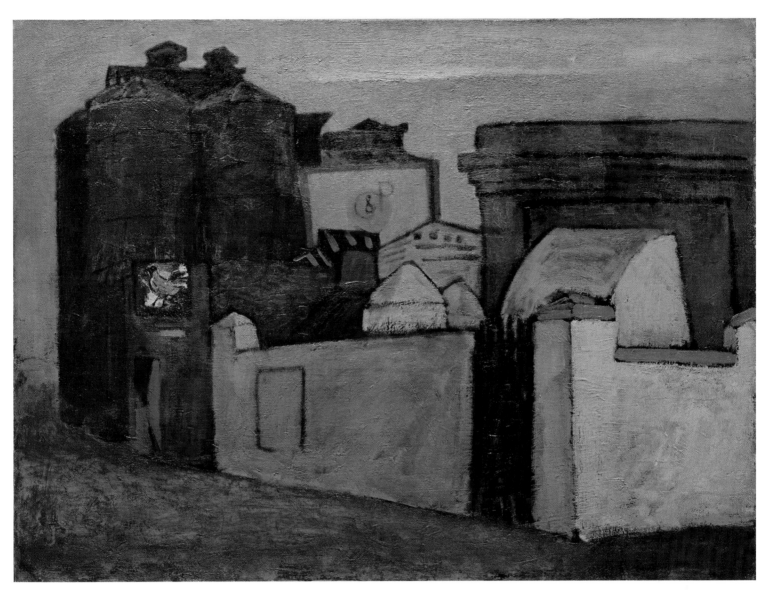

Fig. 37.

Joseph Solman, *The Coal Bin*, 1937. Oil on canvas. 25⅛ x 34". Private Collection.

The second irony is more complicated. Traditional Jews had turned to visions of the messiah for centuries as a source of hope, while secularized Jews in the era after Emancipation typically sought political solutions to the layered problem of persecution. Communism looked, in the twenties and early thirties—as Socialism had somewhat earlier—like the ultimate solution to that problem to many Jews and Jewish artists, especially in New York—even more so when the Soviet Union became the first country to call for a worldwide effort to contain German Nazism in 1935. The massive turn to the political left by Jewish artists, especially in New York, was logically expressed in the socio-political images that, furthermore, echoed biblical injunctions like those in Exodus 22:20–21, Leviticus 19:9, and Jeremiah 7:6 that remind us to care for the poor, the beggar, the orphan, the widow, the stranger—in short, the disenfranchised.

But as Communism seemed to have abandoned its own cause with the Hitler-Stalin non-aggression pact of 1939, such a political ethos became fragmented. Even within The Ten, Ben-Zion and Solman went one way, while the others

went other ways. But some of the most disparate among them continued to share in common the use of messianic imagery, in both traditional and completely revolutionary ways, in the following decades.

Lionel S. Reiss

In any case, the time of The Ten had coincided with the beginnings of what would become the most brutal trauma in the history of the Jewish experience—from Hitler's Nuremberg Laws depriving Jews of basic citizenship rights (1935) to Kristallnacht (1938). Artists other than social commentators such as Shahn or Gropper or Blume and other than members of The Ten had also begun to respond to that trauma even before its development solidified. Still in evolution in the mid- and late thirties, the ideology that underlay Hitler's eventual plans for exterminating world Jewry (among his varied ambitions) was the codification of human traits; systematic comparison of Jewish, Gypsy, Slavic, "Aryan" noses, eyes, foreheads, chins, ears, it was claimed, could yield clarity not only of physical classification but of mental and moral condition. But Hitler's professors had never seen the work of Lionel S. Reiss (1894–1986), born near Jaroslav, in eastern Poland, and arrived in New York City at the age of four. By the 1920s, Reiss's success as a commercial artist was great enough for him to be able to travel and create non-commercial art. It was on one such journey in the early thirties that he first heard Hitler harangue a crowd with rabid antisemitic themes. The artist's desire to record Jewish life, out of an instinctive, almost prophetic sense that he would be preserving the visual memory of something soon to be destroyed, gave to these journeys and the work that came out of them a distinctive urgency.

The result was "a painter's pilgrimage to many lands" made in the early 1930s.[5] From Europe to the Middle East to North America, Reiss sketched hundreds upon hundreds of Jewish faces and places, fifty-eight of which were organized a few years later as part of a limited edition folio-sized book entitled *My Models Were Jews*. The year of publication, 1938, was the year of Kristallnacht when, on November 9, Nazi legal strictures against the Jews of Germany yielded to physical violence on a substantial scale. Reiss's drawings ostensively addressed the question, "Is there a Jewish type?" and answered quite clearly that there isn't, offering a stunning contradiction of the Nazi assertion that one can quantify Jewish—or "Aryan" or any other—physiology (fig. 38).

Through Reiss's eyes and by means of his pen, pencil, and paintbrush, we see blond Jews with blue eyes and black-haired Jews with dark eyes and olive-skinned Jews with piercing eyes. Noses are long and short, straight and bent, upturned and downhooked; lips are thick and thin, wide and narrow; chins are pointed and

Fig. 38.

Lionel S. Reiss, *Jewish Face: French Boy*, 1938. Charcoal and pencil on paper.

blunted, dimpled and flat; hair is short and curly, long and wavy, straight or kinky. Not content with visages alone, the artist also sketched the habitats of the scattered Jews whose faces he recorded. The ghetto in Venice shimmers with light-spangled water; the Jewish quarters of Paris and Worms are smothered in shadow and crowded gloom. He brings us into the interior of the synagogue in Toledo, Spain, that became the Church of Santa Maria la Blanca after the expulsion of Jews in 1492; and into the cemetery in Prague in which the layering of stones reflects the limits of space allowed to Jews in which to inter centuries of the dead. Wagons and shops, street urchins and old beggars, winding staircases, wending alleyways, crumbling walls, and soaring archways reflect the marketplaces and living and working spaces shaped by the millennia that Hitler would nearly succeed in destroying.[6]

Milton Avery

Milton Avery (1893–1964) differed from The Ten and from Reiss in veering away from commentary toward aesthetic concerns so complete as to be almost abstract. In the 1930s and 1940s he carried into the American visual consciousness the Mattissean banner of figure and landscape as flat rhythmic patterns filled out with strident color almost decorative in presentation. The sensibilities presented on his canvases offer a visual and conceptual bridge between both Matisse and American social realists such as Raphael Soyer and the chromaticist abstract expressionists—Rothko and Gottlieb in particular—who would emerge into prominence in the 1950s.

Abstract Expressionism

In the context of the Holocaust and Hiroshima, humanity faced a world broken apart, its sense of coherence utterly jumbled, its sense of positive human potential in shambles. The events of the mid-thirties through mid-forties led not only to the explosion of our sense of what "humanity" *means* but to a debate regarding God's presence or absence in the world. Both explosion and debate offer a context in which to understand the new version of the question of what "good" art is. Whereas that question had been articulated in the first part of the century in terms of regionalist, nativist, and "traditional" sensibilities versus European and "modernist" sensibilities, by the late 1940s and early 1950s the struggle for visual supremacy shifted angles somewhat. Overtly anecdotal and figurative art with clear socio-political messages was being challenged by abstraction and by the

claim that pure art expresses purely formal concerns, that its totality is what is on the canvas and not connected to the world beyond the frame. In other words, the reshaped question became whether "good" art should comment on the world (and how overtly?) or should be a matter of felicitous combinations of line and color without regard for the world and its events. And how does that question encompass the ongoing question of what proper *American* art should be?

Between 1947 and 1953, a new form of visual expression emerged in painting: abstract expressionism. Evolving in America, it offered a new answer to the question of what American art should be. It presented an extroverted energy that reflected a country bursting with a sense of its own potential. While it recalled the fervent, emotion-laden, even violently expressionistic dynamism of El Greco, Van Gogh, and Soutine, the visual form of that emotional energy was entirely abstract—to the point of unintelligibility to many contemporary viewers.

Abstract expressionism's geographic center of gravity was New York City, so that its practitioners have also been referred to as the New York School. But, reminiscent of the earlier pan-European "Paris School," its creators were drawn to the city's energy from various corners of America. It offered the first style to be invented in America, and really the first to be devised anywhere in the artistic world in two decades. European capitals had seen the explosion of fauvism, cubism, futurism, suprematism, neoplasticism, neo-impressionism, German expressionism, dadaism, and surrealism in the first quarter of the century. Now New York raised a new visual voice.

The aspirations of nascent abstract expressionism were messianic, salvational (albeit in a completely secular sense), heroic, and humanistic—by apparent paradox wedding the idea of the social responsibility of the artist to a form of pure internal coherence, without overt relationship to the events of the outside world. Its practitioners inundated enormous canvases with pigment, denying them a traditional boundedness by eliminating the frame. While their visual form offers no obvious historical narrative context, to the initiate they present themselves as commandingly historical in statement, for the gigantic works of abstract expressionism are either reflections of the boundless break-up of the world and our sense of ourselves within it, or attempts to put it all back together.

Indeed, after about 1950, the movement split into two distinct directions along just such lines: "actionists" and "chromaticists." These directions represent two antithetical responses to the world transformed by World War II. Wilhelm de Kooning, Jackson Pollock, and the actionists echo the chaos of a mid-century American and world reality in startling and disturbing cacophonies of color and distressed line, hurled (in some cases, literally) at the canvas and hurtling the viewer into the depths of the canvas. The chromaticists chart a somewhat differ-

ent course: They re-create reality, re-order chaos, restore a center to the off-kilter universe. Interestingly, the Jews among the abstract expressionists mostly chose the chromaticist path, frequently asserting the restorative intention of their works in their titles.

Barnett Newman

Barnett Newman (1905–1970) did this most obviously in paintings with names such as *Covenant #6*, *Onement III*, and *The Name II*. The canvases are heroic in size, inundated with pigment that extends to frameless edges—as if it would extend beyond the canvas itself to the far corners of the universe; as if no borders may be defined in a universe that is defined by Einstein's expansive mechanics (which formed the basis for the atomic bomb) and by the Holocaust. Such paintings also reflect in their very size an inheritance from the 1930s of the WPA muralist tradition. These large unframed works fall between traditional, bounded easel painting and the vastness of wall paintings edged and broken only by the inevitability of floors, corners, or ceilings.

Such works also restore order to the universe; they travel back from the cubist break-up of form that preceded the first World War to the integrity of a single image. The eye is inevitably drawn toward the center of the painting (the "zip," as Newman called it, that held together the unity of opposites). In the case of *Onement III*, the eye is drawn to the centering slash of bright red covenant between divinity and humanity, via the agreement at Sinai where the Israelites are ordained as a "priestly people" and a "light onto the nations," bounded by the deep maroon of truth, that Renaissance period chromatic icon: blue's offshoots as the color of the sky and of truth, with its calm, stable sensibility (fig. 39).

The eye is drawn into the glaring center of a triptych called *The Name II* (fig. 40). Those conversant with the Jewish tradition would be aware, moreover, that, as God's ineffable Name is never uttered outside of prayer by Orthodox Jews, references to the Divinity are offered, in Hebrew, by the circumlocution *The Name*. Such a viewer would thus know that a work called *The Name* offers not only an instance of reunifying the world on the microcosm of the canvas in simple visual terms, but is intended to solve the implied generations' old problem of the Jewish artist: Where do I fit into Western art, which has been, for so many centuries, Christian art? Newman has appropriated that most Christological of formats, the triptych, but has replaced the image of the crucified Christ or the Madonna and Christ child flanked by saints with nothing but whiteness—the absence of color (the absence of that element so fundamental to painting in its traditional, pre-constructivist form)—which is, at the same time, by paradox,

Fig. 39.

Newman, Barnett. *Onement, III*, 1949. Oil on canvas, 71¼ x 33½" (182.5 x 84.9 cm) The Museum of Modern Art, New York. Gift of Mr. and Mrs. Joseph Slifka. Photograph © 2001 The Museum of Modern Art, New York.

most akin of all pigments, to light, the totality of color. Thus Newman has (sym-
bolically) represented, without representing, the God that cannot be visually rep-
resented for Jews. We stare at the absolute *absence* of "thingness" that, at the same
time, is the source and therefore, in a sense, the *totality* of all things.

One could argue the same for Newman's *Stations of the Cross*. A profoundly
significant and traditional Christian series has been rendered in the monochro-
matic style that is the artist's signature. The paintings further answer the question

of how a Jewish artist might respond to specifically Christian themes within Western art, themes that specifically depict God suffering as Man. They do so by portraying God without portraying God; by simultaneously reducing God to formless color and expanding God to overrun a canvas as frameless as God is; by emulating God in creating on the canvas a perfect, unified miniature world that emulates without presuming to mirror precisely the ideal, perfect world that God created at the beginning of time. The canvas's microcosm—the canvas's "miniature order," which is what that Greek word means—echoes the macrocosm. It doesn't echo the macrocosm after millennia of misdirected behavior by a species still only rarely capable of handling its God-given free will appropriately. It doesn't echo the macrocosm torn apart by the negative technologies explored and exploited by humans in the first half of the twentieth century. It echoes the macrocosm as it was in its original Divinely created form—and as it can become again only if and when we humans (not God, nor God *become* human) direct our efforts to restoring it to perfection.[7]

Mark Rothko

So, too, the scintillating work of Mark Rothko. By soaking the canvas in physically watered-down pigments, and eliminating entirely the sense of brush-stroke or palette knife presence, Rothko removes the *process* of creating the work from being an issue for the viewer to confront. He thus counters nearly a century (beginning with impressionism) of the domination of the visual relationship among painter, painting, and viewer by process. By inundating the frameless canvas with broad bands of hue (a trio, or trinity of them) that recede or approach, bracketing, above and below, a broad band that approaches or recedes, he creates a sense of light emanating from a central source. The centralized image asserts itself as a symbol of oneness, of wholeness, of transcendent unity, to which the eye, as the mind, is drawn. Scores of Rothko's works after he arrived at this canonical style exhibit this, from *White Center* of 1950 to *Orange and Tan* of 1954 (fig. 41) to *Light Cloud, Dark Cloud* of 1957 to *Untitled* of 1961. He does not offer the kinds of titles that Newman sometimes does to underscore his intention. But the common theme of his abstract chromaticism, the re-ordering—re-creation— of the world on the canvas as a compelling unity on a heroic scale, suggests a secular visual messianism for a mind-splinteringly fragmented world. Surely this restorative sensibility is what impelled the decoration of a simple white chapel in Houston, Texas, with only a series of gigantic Rothko canvases. Placed all around the viewer on the peripheral walls, they engender a distinctly meditative, spiritual ambiance.

Adolph Gottlieb

Similarly, on the "Burst" canvases of Adolph Gottlieb's fully arrived period, as in his 1960 *Jagged*, scintillating white offers the unifying visual context for the opposed colored forms within its sea: the red sun and black earth, the idealized, ordered geometry of the one, and the chaotic reality of the other (fig. 42). It is as if the instrument of light starting the ordering process of creation is engaged as the instrument of hoped-for, restored, covenantal reunion.[8] Once he finds his definitive style, Gottlieb again and again offers this ideal of unifying apparent opposites by means of the coloristic equivalent of light (the absence of and totality of color, the secular analogue of God Itself), and by emphasis on the same pair of purgatorial colors (black and red) that Ben Shahn so often used to suggest the process of movement from negative to positive.

The prelude to this was Gottlieb's turn from the representational forms he painted in the early twenties to an intense interest in semi-abstract pseudo-petroglyphic and pictographic creations that reflected his interest in ancient cultures. In part this was a reaction to the collapse of or threat to most of "civilization" by the mid-thirties. The stylized images of northwest coast and southwest Native American petroglyphic art and of African masks, the stylized apotropaic eyes on ancient Greek drinking vessels, Klee's semi-abstract pictographic paintings in the twenties, and Miro's biomorphs in the thirties, the appearance of Picasso's "Guernica" at the Paris International Exposition in 1937— all of these Gottlieb synthesized toward his own pictorial imagery, to which works he appended thought-provoking titles: *Oedipus, The Seer* (fig. 43), *Sorceress, Pictograph, Augury, Minotaur, Phoenix, Nostalgia for Atlantis*. By way of these, and by way of the dual notion that the artist must rely on the viewer's cultural training or sharpness for interpreting his work and that art can play a curative role for the ills of society, he arrived, one might say, with his "Burst" paintings, at an abstract re-vision of the hiddenness (*mysterium*) within his own roots, but connected to universal principles.[9]

Newman, Rothko and Gottlieb wrote a letter as early as 1943 to Edward Alden Jewell, art critic for the New York Times, explaining the underlying principles of their emerging aesthetic. They referred to their intention of exploring "tragic and timeless" universal themes. Theirs is thus very conceptual art that evolved, in part, out of long arguments about what "Jewish art" might be and about how to respond to the Holocaust. Those arguments included discussions about Jewish mysticism and specifically the exploration by the sixteenth-century Safed mystic Isaac Luria of the concept of *tikkun olam*. As such, chromaticist abstraction offers itself as a means of secular *tikkun*. Newman even claimed to have learned Yid-

dish in order to read anarchist newspapers, using a specifically Jewish linguistic bridge to the universal issues that spread across his canvases.[10]

Abstract expressionism is a lightning bolt moment in the history of art, a coming of age for American art, and a particular line of thought for questions such as those raised by Jewish American painters in the twentieth century. Each artist falling under that general rubric and each falling within the more specific chromaticist rubric worked in a very subjective style via his own idiosyncratic visual vocabulary. But all worked with a sense—via the existentialist philosophy of Sartre becoming so fashionable after the war—that if our existence has an ethical significance, so will everything that we subjectively produce; this is what gives to the personal some value for humankind at large. The chromatic expressionist works, while abstract in the extreme, have a social, historical, and cultural significance, even a spiritual importance. They are not as thematically distant from the

Fig. 43.

Adolph Gottlieb, *The Seer*, 1950. Oil on canvas. 59¾ x 71⅝ in. Courtesy of the Phillips Collection, Washington, D.C. © Adolph and Esther Gottlieb Foundation/ Licensed by VAGA, New York, NY

(Facing page) **Fig. 42.**

Adolph Gottlieb, *Jagged*, 1960. Oil on canvas. 72 x 48". © Adolph and Esther Gottlieb Foundation/Licensed by VAGA, New York, NY

figurative, overtly narrative, social realist works of the previous decades as one might think.

From Chromaticism to Color Field Painting

Ad Reinhardt

The chromaticist abstract expressionists created a new form of painting that can be viewed simultaneously as a series of exercises in color and form and as responses to the massive chaos that seemed to have overwhelmed civilization by the middle of the century. The color field offerings of Ad Reinhardt (1913–67) reduce reality to geometric sequences of colors that extend left and right, up and down, as well as into and out from the picture plane, as in works such as his 1950 *No. 88* or *Untitled (Red and Grey)* (fig. 44). The microcosm of the canvas restores the order that once defined the macrocosm, with a three-dimensional depth that draws one's eye inward, and that defies the traditional distinction between two- and three-dimensional art, but not by the traditional Albertian means of a perspectival vanishing point.

Reinhardt offers his own version of *tikkun olam* on the canvas. The irony is that he ultimately asserted a desire to distance art from issues: particularly his later paintings, reduced to all black (totality of color; absence of color), are intended, it seems, to cut out everything "that is not art." But they can't eliminate the spiritual, which, as Ellen Johnson wrote, means that those paintings "are as mystic, *malgre lui*, as anything of Rothko or Newman."[11] That said, one might argue that his work offers *tikkun* in spite of his conscious intention not to be associated with such thinking, particularly when the cross emerges to dominate his surfaces so distinctly, as in his 1964 *Black Painting* (fig. 45).

Philip Guston

On the other hand, Philip Guston's (b. 1913) engagement of abstraction from about 1950 fell between actionism and chromaticism. His gestural style is far more subdued, far less violent, than that of Pollock or de Kooning. Delicately chaotic, soft but rough-edged (far less smooth and ordered than the work of Newman or Rothko) swatches of pastel hues focus the viewer's eye toward the center of the canvas which they dominate. His microcosmic resolution of chaos is simultaneously earthy and vaporous (fig. 46). His introduction of flotsam and jetsam from everyday life into his paintings would usher in new image painting in 1969.[12]

Helen Frankenthaler

One of the important and innovative artists of the next "generation" whose work would assert no particular relationship with her Jewishness is Helen Frankenthaler (b. 1928). She was barely twenty-four years old when she placed a large— 86 by 117 inch—slab of raw, unprimed canvas on the floor of her studio and, after having sketched out a series of abstract swirls and sweeps with charcoal, soaked it with pools of diluted oil paint, thus pioneering the "soak stain" style of abstraction for which she became famous. The resultant work was named *Mountains and Sea*, a consequence of the association she acknowledged between this painting and watercolor nature landscapes she had done in Nova Scotia just before, rather than because this was intended to be other than a cerebral landscape. "I think there is [landscape in my work], but it's not through a conscious effort. I'm not involved in nature, per se," she commented in an interview many years later.[13] The combination of drawing and brushless painting, the simultaneous gestural and chromaticist aspects of her work, make her a unique bridge not only between actionist abstraction—particularly that of Pollock—and the work of Newman, Rothko, and Gottlieb. She had also forged what would become the connection

between the abstract expressionists of the 1950s as a whole and the color field artists who ushered in the 1960s.

The technique of Frankenthaler's work draws from accident and improvisation, and, with her tendency to soft-edged colors and fluid shapes, also seems to mediate, in visual and textural effect, between oil and watercolor. The softness is enhanced both by the water consistency of the paints soaking into the canvas and by the way shapes run against each other without sharp linear interventions. The alchemical opposition of oil and water, together with the combination of heroic proportion and delicate colors, presents a series of parallel paradoxes: the order of nature and accidental chaos, lightness (in all senses: weight, dawn/dusk color-

Fig. 46.

Philip Guston. *Painter's Table,* Gift (Partial and Promised) of Mr. and Mrs. Donald M. Blinken in memory of Maurice H. Blinken and in Honor of the National Gallery of Art, Photograph © 2002 Board of Trustees, National Gallery of Art, Washington, 1973, oil on canvas.

ation, energy) of mood and power against the eye, drawing and painting, water-color sketch and completed oil painting, emotion and intellection, flatness and a sense of expansive space. "That feeling [that] involves certain elements of space and light, scale, 'the moment caught'" to which her work aspires seeks all the way back to Veronese, carries through the impressionists and arrives, by way of the abstract expressionists and the color field painters toward the twenty-first century.[14]

Morris Louis

In the evolution out of chromaticism toward color field abstraction in the mid-1950s and early 1960s, Morris Louis (1913–1962) is a dominating figure. His work also offers a further twist to the issue of "Jewish" intentionality. He was born Morris Louis Bernstein in Baltimore to immigrants from Russia. After training at the Maryland Institute of Fine and Applied Arts and a subsequent ten-year period in New York City, he returned to the Baltimore area after World War II. His colleague Kenneth Noland eventually introduced Louis to sculptor David Smith and to New York art critic Clement Greenberg, who, as sounding board, commentator, and exhibit organizer, would have a profound influence on Louis's career.

Within the contexts that Greenberg continued to shape, Louis and Noland were affected by the work of Jackson Pollock, Robert Motherwell, and Willem de Kooning, and were particularly taken with the methods of Helen Frankenthaler. Renowned art historical lore recounts how the two Washingtonians, brought into her studio in 1953 by Greenberg, were inspired by her abstract expressionist nature paintings—in particular *Mountains and Sea*—to turn to experimentation with staining paint into raw canvas. Louis' *Charred Journal* series of 1951 had already established a clear association with Pollock's draftsmanship during that era, suggesting, though, a degree of figuration, or at least specific letter-forms—perhaps Hebrew letter-forms—on Louis' smaller-sized easel scale. That series, evocatively titled and largely devoid of color, was created in the same year and on the heels of a little-noted painting called *Untitled (Jewish Star)*.[15] Who can say precisely what an artist is thinking when he paints, especially one who spoke little, corresponded little, and kept no notes, records, or diaries regarding his work, and who rarely allowed anyone, including his wife, into his studio? Yet it is hard to imagine, as the repercussions of the Holocaust were rippling through the New York art world of the late 1940s and early 1950s, that Louis would have been immune to thoughts of that horror. Is it merely a coincidence that this single painting, which seems to allude directly to it, is immediately followed by the

almost identically styled *Charred Journal* series, even if that series ostensively refers to Hitler's burning of books and not of people?

Soon after *Charred Journal*, Louis's painting shifted dramatically (after seeing Frankenthaler's work) toward color, and toward more complete abstraction. A unique marriage of gesturalism and colorism offers an exploration, it seems, of light itself in well-structured compositions that invite the viewer into richly pigmented depths; pure, disembodied colors afloat in expansions across the picture plane, framed by pure colorless white that intermediates between the colors within the picture plane and the world outside the canvas; romantic in a sense, evoking intense varied subjective responses from varied viewers.[16] This first great series, created in the mid- and late 1950s—the *Veils* series, in which lyrical curtains of color vie for foreground consideration on heroic-sized canvases awash with pigment—makes clear Louis' relationship to the work of Mark Rothko and Barnett Newman (fig. 47). "Louis translates the chromatic calculations of Rothko into something that might be called chromatic mysticism," Stuart Preston wrote at that time, while Martica Sawin noted how the *Veils* belong "to a particular realm of experience to which the works of Rothko and Newman, in their different ways, also pertain."[17]

What realm of experience? What form of mysticism? What Preston perceived of Rothko and thus of Louis is more real, perhaps, than he knew. As we have seen, Rothko and Newman were engaged with other Jewish artists like Adolph Gottlieb in discussions regarding Jewish art. And Louis made repeated trips to New York and participated in—or at least listened in on—their discussions. Fascinated by Jewish mysticism as well as by the question of Jewish art, Rothko, Newman, and their circle saw an association between their objective, non-narrative chromaticist explorations and the notion of repairing the universe in a specific post-Holocaust sense.[18]

It may not be unreasonable to include "Holocaust experience" in the "particular realm of experience" to which Sawin referred, and "Jewish mysticism" in that "something that might be called chromatic mysticism" to which Preston referred in their respective comments. Like Newman, Rothko, and Gottlieb, Louis saw himself in a kind of visual opposition to "the positive accomplishments of Pollack [sic] . . . and the muscular painters. . . ." He perceived his work as different from that of "the good Anglo-Saxons and the difference adds up to the sameness of focus," as he wrote to Clement Greenberg in June 1954, when he was in the midst of the radical shift toward his canonical work.[19] But nowhere does he explicitly (or perhaps even consciously) connect the *Veils* or subsequent canonical series to Jewish concerns.

Fig. 47.

———

Morris Louis, *Beth*, from *Veils* series, 1960. Oil on canvas. Philadelphia Museum of Art: Purchased with the Adele Haas Turner and Beatrice Pastorius Turner Memorial Fund. © 1960 Morris Louis.

Fig. 48.

Morris Louis, *Delta*, from *Unfurleds*
series, 1960. Oil on canvas. Philadel-
phia Museum of Art: Centennial gift of
the Woodward Foundation. © 1960
Morris Louis.

Indeed, those series evolved in three primary directions. As his power of composition reached a level of superb discipline, Louis moved by 1960 to a striking new format, the *Unfurleds* series (fig. 48). In these paintings, areas of color streams frame a huge central wedge of intensely white, unpainted, and even unprimed canvas. Like the *Veils*, they draw from the artist's skill in draftsmanship and colorism, but expand the dialogue between positive and negative space he had introduced in the *Veils* series. Among the aesthetic and conceptual images that they suggest is that of nonvisual visual art. If, in traditional terms, a painting is contained within a frame, then the color rivulets are the frame for a "subject" that is, in these works, the absence of image and color (pure white). Yet, as we have discussed in the context of Newman's work, white is simultaneously the totality of color, as it suggests light. Therefore pure light is "framed" in the *Unfurleds* by its prismatic progeny.

Perhaps Louis's unconscious helps him to produce works that simultaneously

accomplish several ends. They re-order the universe on the canvas's microcosm (a form of visual *tikkun olam*). They portray the Orderer of the macrocosm without portrayal (thus, reminiscent of Newman, offering a Jewish solution to the problem of Christian artistic tradition). They comment at the same time on the *absence* of the Supreme Orderer, as humans devoured humans during and since World War II. Even as we recognize that it is impossible to assert any of these interpretive claims with certainty, one can surely assert the fusion between emotion and intellect that the *Unfurled* series represents. On the one hand, the multiplicity of colors and vibrating contours call forth a subjective, emotional response from the viewer. On the other hand, both the architectural structure, and the fact that the artist probably never actually saw a single one of these pieces stretched or hanging means that they were all highly conceptual.[20]

By early 1961, Louis was shifting that conception in a third direction: the *Stripe* paintings. He created pillars of color, stripes of pigment pouring down canvases smaller than those of the previous two series of works, using asymmetry as a dynamic structural element. In other words, Louis carried further the idea of the unpainted canvas as a component in his composition. The negative element, pushed to the side by the stripes occupying not center but off-center space, becomes positive in offering a dynamically imbalanced balance to the pigmented side of the painting.[21] Students of Louis's *Stripe* paintings often see them as harbingers of the minimalist art of the later 1960s, even as the *Veils* and *Unfurleds* are seen as continuous with the chromaticists. In other words, Louis's work joins together—or falls between—different categories, not easily satisfying those who need to place ideas comfortably in frames. Perhaps the same may be said for the putative Jewish aspects of his work.

Intellect and Emotion

Leon Golub

Dramatically different from such visual thinking is the work of Jewish painters who apply overt visceral energy to the subject of the Holocaust. The paintings of Leon Golub (b. 1922) in the mid-1940s and 1950s are among the earliest of these. In his lithograph *Charnel House* (1946), with its deformed faces and bodies twisting, turning, and melting into each other, humans have become taffy, pulled and pushed into amorphous anonymity (fig. 49). His *Burnt Man* series uses the Holocaust as an explosive stepping-off point for myriad visual representations of how the contemporary world has twisted sacred and profane power and allowed tech-

Fig. 49.

Leon Golub, *Charnel House*, 1946. Lithograph. Courtesy the artist and Printworks, Chicago, IL.

nology to devour humanism. The specific starting point for him is the Jew as historical victim, but "that's not all of it. It also had to do with this sense I had of myself as estranged—as marginalized . . . [by the] domination and violence, . . . the existential fatality" of the Western world in the twentieth century.[22]

The phrase "Jewish American artist" fits Golub well, even as his Jewish themes have universal resonance. On the one hand, the Holocaust connects to Hiroshima, which in turn connects to Vietnam—". . . the question is who am I painting? . . . I am painting these warrior-citizens in the most extreme of human conditions, the response to terror. Dachau, Hiroshima, Vietnam . . ."[23]—but also to the range of twentieth-century killing fields, from Armenia to Rwanda, which are not American but part of the world heritage of horror in this century. On the other hand, his images of flayed and torn figures are offered as a symbol not only of human experience at large in the twentieth century, but of specifically Jewish experience across the centuries. Thus the flayed torso that sears the viewer's eyes in *Thwarted* (1953) recalls the famed Belvedere torso housed in the Vatican museum, and is intended to haunt the secular-Christian world with a Holocaust-

inspired image that offers a very specific understanding of the ongoing history of human dehumanization "inspired" by love of God. The Golub image recalls the questions that have been raised for half a century regarding Pope Pius XII and other Catholic leaders who were silent while Jews were being murdered.

Alice Lok Cahana

By the 1970s, a growing number of Jewish American artists were focusing on the Holocaust.[24] This included survivors, many of whom found such a focus a way of wrestling with demons that no words could effectively address, including Alice Lok Cahana, born in 1929 near Budapest, and trapped as a teenager during 1944 and 1945 in a succession of concentration camps. Arriving in the United States in 1957, she was already painting as a lyrical abstractionist, until she revisited Hungary in 1978. The result was re-awakened need to speak visually about her Holocaust experience. Cahana's semi-abstract paintings and collages of dark, but often also pastel, coloration, done as a series between 1978 and 1985, are entitled *From Ashes to the Rainbow*.

They transform grey horror into color, fulfilling the fantasy that had helped her to survive Hell: that her brush would turn blackness to bright hue in recording it someday. Moreover, as a student of Jewish mysticism, she was aware of the Kabbalistic inquiry into the transmutation of matter into spirit, of the aspiration to ascent. As a colorist in the tradition of Morris Louis, and political observer in the tradition of Goya, Cahana found herself on new ground in returning to her birthplace. Sarvar, 120 miles from Budapest, offered no memorial to its slaughtered Jews. Nobody she queried recalled her mother. The need for visualized memory was combined with the imperative to wrestle cosmos—order—and some transcendent positive sense out of chaos.

The very materials and techniques, beyond the details of style and subject, are metaphors for the reality they convey. The surfaces are burned, scratched, stained with blood-red; images are grafted, buried, partially eaten away—duplicating the fate of human beings swallowed in the camps of the artist's experience. In *Arbeit Macht Frei*, a conveyor belt–like pattern leads the eye toward the unmistakable gape of an Auschwitz oven over which the fragment of the sign from the entrance to that inferno, *Arbeit Macht Frei* (*Work Makes One Free*) is suspended.

But much of Cahana's work ultimately leads upward, as in the wonderfully colored *Jacob's Ladder, Dream* (fig. 50). Railroad tracks have become rungs of upward motion, up out of the dark ground, as if a rainbow of covenantal promise is emerging: It is after wrestling with God that Jacob becomes *Israel*. But there is irony, too, since the heavenward railroad track/ladder reminds us that Rudolph

Fig. 50.

Alice Lok Cahana, *Jacob's Ladder: Dream*, 1986. Mixed media. Courtesy of Alice Lok Cahana, Born in Budapest, Hungary; American painter and writer.

Hoess, commandant of Auschwitz, used to refer to the tracks to his Camp as *himmelweg*—Heaven's Way—since those arriving in railroad cars were inevitably arriving at a waystation to death. The ascending and descending angels must be the innocent souls of the deceased in this work.

R. B. Kitaj

R. B. Kitaj (b. 1932), strictly speaking, sends us back toward Jacob Epstein. Although American-born (Cleveland-born and raised), Kitaj was an eventual emigré to England, where most of his career as a painter has been lived. Yet he must be included briefly in this discussion. His work, diversely built on metaphors and allegories, is a labyrinth of dreams, intertwisted with reminiscences of Giotto, Brueghel, Velasquez, Ucello, Michelangelo, Titian, Tintoretto, Goya, Bazzano, Degas, Van Gogh, Cézanne, Bomberg, and reflections on his abandoned home, America. Early on, he used baseball as an idealizing self-reflective metaphor, but by the 1970s, the labyrinth begins to twist in new directions, via the artist's extensive reading, toward an overt consciousness of his Jewish roots, and particularly, of the Holocaust: "I used to think," he comments, "that you were a Jew only if you wished to be. It was the murder of European Jews that changed my thinking, once I became aware of it . . . I had no religious or cultural background, but the question of a Jewish art began to interest me."[25]

Suddenly aware of the issue of "Jewishness" in large part because of the 1967 Arab-Israeli war, the artist began to seek a Jewish symbol analogous to the baseball diamond for America and the cross for Christianity and Christian art. By the mid-1980s, the chimney had emerged—as in *The Painter (Cross and Chimney)*— a reference to the ovens of Jewish experience in the diaspora, culminating with Auschwitz (fig. 51).[26] We see also his 1985 re-vision of *Hamlet's Ghost (King of Denmark)* wearing a yellow Star of David, as did the Danish monarch and his people who ferried Danish Jews to rescue from the Nazis.

Kitaj is important to our discussion because his search for a symbol presents us with the first absolutely overt address of how to place "Jewish" art within Western art, and his focus on the chimney as the most appropriate symbol for Jewish art in the second half of the twentieth century is significant. The Holocaust emerged as the reference point for Jewish self-definition as the first generation after the Shoah yielded to the second, and it continued to influence the work of American Jewish painters to the end of the century.

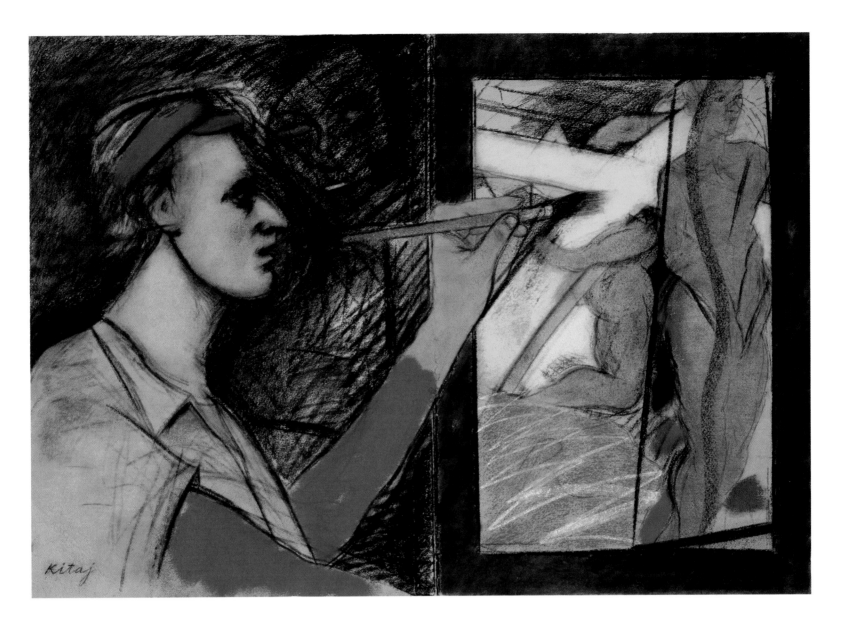

Conceptual and Pop Art

Sol LeWitt

Kitaj's extreme intellectuality also leads back toward abstraction by way of his contemporary, Sol LeWitt (b. 1928). LeWitt, in a sense, continues Ad Reinhardt's repeated rhetorical efforts to reduce art to an absolute, for as a father of conceptual art, LeWitt produced both sculpture that is austere, unadorned (often white in color) and paintings and drawings that are either reduced to a simple line on a wall or to a mesmerizing, rhythmic repetition of lines, but in any case completely thought-out before the pigment touches the surface. His 1964 *Wall Grid* is a wooden structure, about six feet square, the interior of which is a pattern of horizontal and vertical crossbeams, the whole painted with black acrylic and hung on the wall.[27] The wall itself thus becomes part of the painting—or is it

Fig. 51.

R. B. Kitaj, *The Painter (Cross and Chimney)*, 1984–1985. © R. B. Kitaj, courtesy, Marlborough Gallery, New York.

a sculpture, since the wood 2-by-2s have the volume that, by definition, would cause us, in traditional terms, to call it sculpture? Yet it hangs on the wall like a painting, even as its blackness suggests the non-color of non-painting, and the colorlessness-suggesting white that is part of it is actually *not* part of it, but part of the wall where it rests.

In myriad *Wall Drawings*, as LeWitt prefers to call them (rather than "paintings"), he has carefully calibrated turn of line and nuance of color, which a team of assistants then paints directly onto the wall. The careful and complex schemata cause one to think of Roman wall paintings and frescos by Giotto and Michelangelo, with the large blocks of pigment that he thrusts before the viewer's eye (fig. 52). On some walls of entire rooms, LeWitt plays with perspectival illusion, as if the viewer were confronted with three-dimensional objects in space or convex and concave forms, and not a series of pigmented lines on a flat wall.

LeWitt's work leads also toward minimalism: more of the work is intended to come, it would seem, from the viewer's mind than from the artist's brush. Interestingly, his *Sentences on Conceptual Art* (1969) notes from the beginning that "conceptual artists are mystics rather than rationalists" just as he observes that "ideas can be works of art; they are in a chain of development that may eventually find some form . . ." (Sentence #10) and that "these sentences comment on

Fig. 52.

Sol Lewitt, *Wall Drawing No. 681 C,* The Dorothy and Hebert Vogel Collection, Gift of Dorothy and Hebert Vogel, Trustees, Photograph © 2001 Board of Trustees, National Gallery of Art, Washington, 1993, color ink washes. © Sol LeWitt/Artists Rights Society (ARS), New York.

art, but are not art" (Sentence #35). Thus similar to his work, his writing *about* his work suggests an inherent contradiction of the medium as we ordinarily think of it in the Western tradition. He verbalizes a turning away of visual art from the visual if "visual" means style, subject, or symbol perceived by the eye. The eye is reduced to a conduit for conceptualization and discussion.

Such overt and abstract seriousness that was pushing American art into and beyond the 1960s, had its apparent opposite: the swallowing up of all that is most banal, commercial, and silly in American culture and regurgitating it onto the canvas. The movement came to be called pop art. The *New Realist* group exhibition at Sidney Janis Gallery in December 1962 was the first expression of pop art as a "movement." Images from newspapers, television, magazines, comic books, and advertisements had begun to inspire a number of diverse artists in a direction that is actually *not* the opposite of conceptual abstraction, for it is deadly serious about forcing the viewer to reconsider inherited preconceptions regarding the definition of art. Thus both "movements" deliberately transgress the line between "art" and other visual/conceptual realms, but by means of different vocabularies.

Roy Lichtenstein

For example, Andy Warhol (a Catholic) forces us to consider both the artistry of color and shape that went into the packaging of a soup can to draw our attention to it in the store, and the fact that we redefine that artistry as "art" if it is placed on a canvas hung on a gallery wall rather than wrapped around a metal cylinder placed on the supermarket shelf. Among Warhol's pop artist "colleagues" were several Jews. Roy Lichtenstein (1923–1999) focused like a zoom lens on comic-strip fragments from the imaginary lives of those around and beyond us, carrying more reality for us than our own lives, elevated to greater significance—and thus why not elevate them to Art?! Again and again, details of love and war—the two staples of human experience wrought more intense though comic-book characters and their experiences—assault the eye, their benday dots multiplying on his canvases like enormous snowflakes in a winter storm (fig. 53). The scale and directness obliquely extend the impact associated with the heroic paintings of abstract expressionism. This comic book reality is art-in-America, which comments on art, on America, and on art in America. It asks where the lines between categories should be drawn—if at all.

Fig. 53.

Roy Lichtenstein, *Blam!!* 1962. 68 x 80". Oil on canvas. © Estate of Roy Lichtenstein.

Larry Rivers

Larry Rivers (b. 1924) is also associated with pop iconography as far back as the late 1950s—from images of dollar bills to cigarette advertisements to pseudo-cinema-montage conveyed by depicting the same figure in two poses within the same frame.[28] Rivers' brushwork early on seems to connect him to the gestural abstractionists. His 1958 *Second Avenue*, for example, offers a chaotic crystallization of energy and activity. There is nothing overtly Jewish in most of these earlier works, unless we assume that the image of the dollar bill is intended to suggest, tongue-in-cheek, a particular stereotype that would be associated with the

artist by way of his Jewish identity; or that the stretch of Second Avenue portrayed is located well down toward the Lower East Side and its once Jewish array of shops and passersby.

During this same period, however, the artist was also exploring overtly Jewish subject matter, focusing on the representation of his ancestry and his identity in works such as *Europe II* (1956) and *Bar Mitzvah Photograph Painting* (1961), in which parts of photographs were collaged onto the canvas and/or painted over. He was also experimenting with pop expressionist plays on iconic American images (*Washington Crossing the Delaware*, 1953) and with bold monumental subjects (*The History of the Russian Revolution: From Marx to Mayakovsky*, 1965). So it is not surprising that sooner or later he imposed the pop collage-like multi-layered style and gestural brushwork to another—specifically Jewish—aspect of "history painting," which genre he had been so instrumental in rejuvenating in the second half of the century.[29]

In the early 1980s, commissioned by Sivia and Jeffrey Loria, Rivers produced a massive three-part work entitled *History of Matzah: The Story of the Jews* (fig. 54). The vast triptych offers a kind of cinematic sweep across a "screen" 45 feet wide, and also relates to comic strips, with its combination of explanatory text and image. It mixes photographically precise images with splotches and stretches of strong color against the unifying background of a matzah pattern. The un-leavened bread of the Passover meal, which symbolizes both affliction and the deliverance from it, also offers a tawny color reminiscent of the Middle-Eastern landscape where Judaism originated.

The implications of a triptych are inescapable for the issue of Jewish artistic identity: It is, as we have earlier observed, a quintessential form of Christian visual self-expression, suggesting the triune God of redemptive mercy. Rivers uses that frame with a certain degree of irony—the merciful aspect of that God has been too often ignored or forgotten by His adherents where their treatment of Jews is concerned—to sweep forward from the Israelite-Judaean period before the dias-pora, with varied images of Moses, Saul, David, as well as Jesus-as-Jew, celebrat-ing the Passover Seder *cum* Last Supper. Interspersed with images from Persian and Greek cultures contemporaneous with these figures, the figures themselves are all transmutations of icons of Western, Christian art. Rembrandt's *Moses with the Tablets of the Law*, Michelangelo's *David*, Leonardo's *Last Supper* focus the historical sweep—in part. But they are fragmented or altered: David is circum-cised, for instance, and more obviously and personally, Rivers uses the face of his cousin Aaron for both Moses and Jesus.

In the middle wing of the triptych, the artist carries the viewer to images of European Jewry, where the background matzah of deliverance gives way to the

Fig. 54.

Larry Rivers, *History of Matzah: The Story of the Jews* (part one detail; left wing), 1982. © Larry Rivers/Licensed by VAGA, New York, NY

map of dispersion. Intentionally anachronistic images of Assyrian-imposed Israelite exile commingle with images sweeping from Temple Menorah to Spanish Alhambra to Cossack hordes to dancing Hassid to Polish Timber Synagogue to Spinoza to Herzl and the advent of Zionism. The Lorias appear here, as participants in the "Yom Kippur at the Synagogue" service adapted from Mauritzy Gottlieb.[30]

The third canvas follows Jewish immigration to America, where the map of dispersion yields to the map of emigration routes before again becoming matzah to complete the image frame. The Statue of Liberty is sandwiched between immigrants' eye examinations, sweatshop seamstresses, and steerage passengers in 1893 on the SS *Pennland*. We have returned to the world of arrival recorded eighty years earlier by Stieglitz's camera. Elsewhere in the composition, Nazi-era signs forbidding Jewish use of parks appear with images of Eastern European Jews sitting in a New York park reading Yiddish newspapers.

In creating this vast sweep, it is ironic that Rivers has fashioned with a twentieth-century visual vocabulary a work reminiscent of the sort of Renaissance- and Baroque-era dynastic allegories in which patrons were depicted by the artist in the company of historical or religious luminaries. The Baroque era of Western art history, with its counter-Reformation theological tone, helped push the West in a secularizing direction that would ultimately lead to the emancipation of Western European Jewry. Yet it was still an era in which Jews were excluded from the mainstream. But with this gargantuan work, Rivers has brought the outsider in, on his own terms. The complex issues of identity that he sums up will be further addressed in the generation that follows.

Toward Century's End

PART III

Social Commentary and Spiritual Seeking

In the 1960s and early 1970s, America experienced a dual social and cultural transformation, among other things. The expansive prosperity and self-confidence of the fifties came up against the encroaching ugliness of involvement in Southeast Asia and most obviously Vietnam, with an overflow of questions as to our direction as a nation. Ambivalence about—even hostility toward—national politics as manifest in growing opposition to that involvement coincided with a growing interest in ethnic, racial, and spiritual identity, so that the image of America as a melting pot was evolving into that of a tapestry of interwoven threads or a rainbow of diverse colors.

The Jewish artistic activity that we have already observed interwove obvious sociological (more often than purely political) commentary with the aesthetic question of what visual art should *be*. To the abstract painting that carried toward conceptual and minimalist art, pop art's various manifestations (especially the works of Lichtenstein and Rivers) responded with emphatically figurative imagery. But significant proponents of figure painting are found in other corners of American painting in and beyond the 1960s and 1970s.

Philip Pearlstein

Philip Pearlstein (b. 1924) emerged during this period as one of the pre-eminent figurative masters and a key exponent of a revived realist style. Here, too, there is a twist. For instance, in *Two Female Models with Model of Tall Ship* (2000), he has done what painters *prior* to impressionism tried to do: Eliminate the presence of the brush from the viewer's eye, completing the illusion that we are seeing a real figure in volumetric space, and not pigment brushed or palette-knifed onto a flat surface (fig. 55).[1] But he deliberately breaks traditional compositional rules. The foreground figure is partly cut off; we don't see her upper torso, neck, and head, nor the end of one foot; she doesn't quite fit the frame. The kind of narrative that we might append to a portrait of a person is hardly possible.

Her counterpart—placed in double counterpose: facing opposite, her face quite visible, but also counterbalanced by her own reflection and the opposite reflection of the first model—is viewed through the webbed rigging of the ship, its tail end also cut off by the image edge. That rigging, like the colorful quilt on which all three models rest, underscores the patterning that dominates the work. The fact that a pair of *women* has been depicted is undercut: The unclassic composition is one of lines, shapes, colors, some of which happen to be flesh tones and attached to what we readily recognize as human bodies.

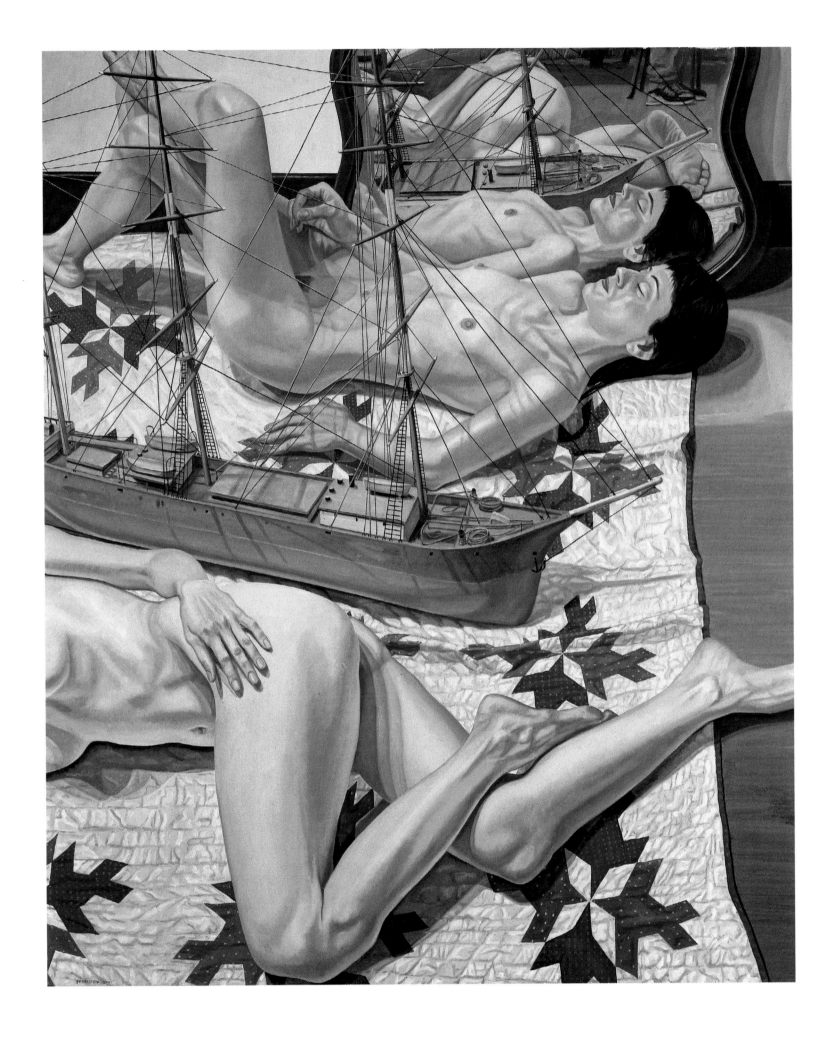

Those bodies have become almost an abstraction. Pearlstein offers an implied comment on the history of depicting nude women as *objets d'art* by eliminating features of one model that would help us identify her as a particular person and offering the other as an analogue of the ship that partially obstructs our view of her. He twists this viewer-object relationship further by allowing us to see the mirrored reflection of the foot and lower leg (which he has, in essence, cut off from both models) of a presumably male viewer: the artist himself? Us? Whoever he is, he stands where we are standing, and so is a metaphorical reflection of us, regardless of who he is literally. For all of the illusory reality that connects this work to an array of Renaissance and Baroque masters (Titian's silky texture springs most readily to mind), it is a composition derived from an abstract twentieth-century sensibility.[2]

Gerald Wartofsky

The goal of Gerald Wartofsky's paintings is "to emulate in a personal form the complexity of structural design that the Renaissance and Baroque masters had forged, the intricacy of their imagery and technical beauty," as he commented in the early 1990s.[3] One feels the careful patina of the Renaissance melting against the ideology of the surrealists, as subtle perfections of figurative elements subside into abstract, phantasmagorical contexts. Wartofsky (b. 1935) is inspired by music, particularly Mahler—richly woven tonalities, lush and dark but also light—and by the poetry of Rilke and Juan Roman Jimenez and others. But the fourth dimension—perpendicular, as it were, to painting, poetry, and music—is dance. In conveying the movement of dance in the static instrumentation of brush and canvas, Wartofsky's paintings scintillate with movement.[4] The delicate intensities of color, the dappled light as if reflected from water, recall the twisting tessellated reflections from Venetian canals.

His paintings reflect again and again from the literary mirrors of the Bible and the Talmudic tradition. And, not surprisingly, Jewish mysticism is part of the artist's vocabulary, from his early *Conjurer* (1962–1965) to his later *Permutation of the Aleph* (1984–1986) to his more recent *Evocation of the Shin* series (1993). In this last, the Hebrew letter *shin* that represents the protective power of God conveyed by the God-name *Shaddai* is placed at the center of the painting (fig. 56). In the terms of later Jewish mysticism, *Shin* is the smashing of the shells that encase the primordial light scattered by Adam and Eve when they disobeyed God. The breaking of the shells allows the light to regather, to return to its unified source. The *shin* paintings also include a dried-flower image recalling the death-life cycle imagery in many of his other works, together with dancing hands.

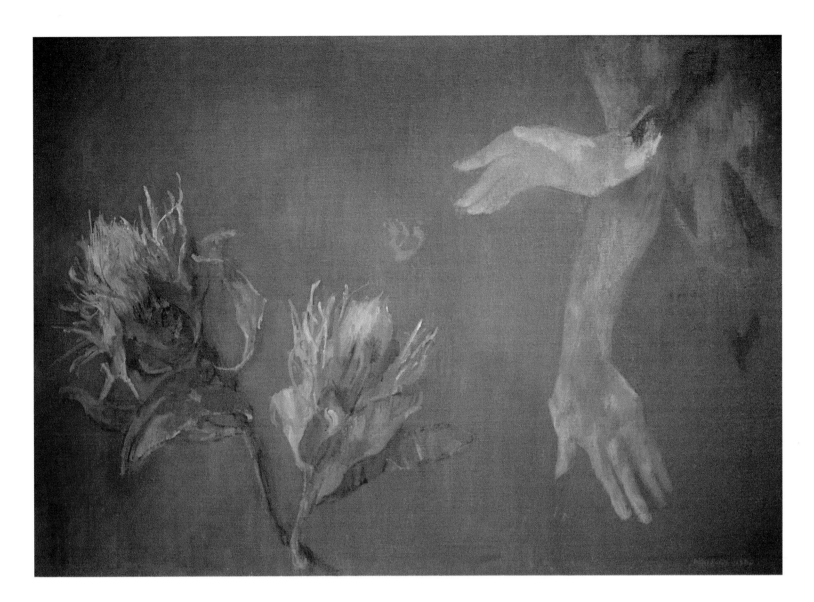

These are the hands of the high priestly benediction in the destroyed Jerusalem Temple. They are the hands of God, animating Adam on Michelangelo's Sistine ceiling. They are the conjurer's hands. Literally, though, they are the hands of his wife, Karin, who is the dancer who inspires him.

Fig. 56.

Gerald Wartofsky, *Evocation of the Shin II*, 1993. Oil on linen. 39" x 27½". Collection of the artist.

David Einstein

The ties between Wartofsky's painting and his Jewish identity are often very strong. Such associations are similarly strong, albeit abstractly, in many of David Einstein's (b. 1946) paintings. Works like *Light Echo* (1975) pull us into landscapes of light in a manner reminiscent of Morris Louis' *Veil* paintings (fig. 57). This connection was acknowledged by the younger artist. "I was most intrigued by the way in which Louis could overlap layers of color and still retain a soft translucency," he wrote in the early 1990s, while also explaining how he began, in the 1970s, "to think of land and sky forms as strata of color which can be com-

bined in various ways to portray natural phenomena . . . [and] compositions . . . that could exist as an autonomous reality, apart from the visual reality of one's everyday life."[5]

The connection between color and light and between light and the process of creation recounted in Genesis I offers one part of the perspective that Einstein articulates as Jewish, for "Let there be light!" is the *only* and *absolute* beginning for Jews, whereas for Christians it is the preliminary to the more significant beginning articulated in John I, wherein the word becomes flesh. For Einstein, a further point of contact between his canvases and his heritage may be found in the last chapters of Exodus. For there we find reference to the *parokhet*—the curtain, or veil—that separates the Holy of Holies wherein the Tablets of the Law reside, from the outer regions of the Tabernacle, which is the tangible intermediary between the intangible God and the Israelites. The artist describes his paintings as visual echoes of that veil. They also echo that thinnest of veils that always remains between the Jewish mystic and the invisible God to whom he ascends and with whom he seeks intimate, ecstatic interface.

The *Color Veils* are at once pure exercises in color theory and heirs to the engagement of Jewish mystical thinking, interwoven with the concern for *tikkun olam*—repairing the world, completing its moral and spiritual ordering—that we have observed in the chromatic microcosms of painters from Barnett Newman and Mark Rothko to Morris Louis. As such, Einstein's *Color Veils* offer a layered pattern of continuity with both the Jewish spiritual past and the more recent visual heritage of Jewish painters in America.

Susan Rothenberg

Susan Rothenberg (b. 1945) first gained notice in the late seventies as she introduced outlined animal forms—a "subject"—onto the austere minimalist (subjectless) canvas, producing what was called "New Image Painting" in the so-named exhibition in 1978 at the Whitney Museum (fig. 58). Her work is particularly indebted to Philip Guston as her chromatic gestural style has defined itself in the two decades since then, in its combination of chromaticist and gestural feel over which a rough-hewn figure is superimposed.[6] By the nineties, the harsh light of the desert environment where she came to live and work had reinforced the inclination to emotion-laden physicality expressed in strident colors and thickly thatched brushstrokes that connect personal anxieties to the age of anxiety in which we all live.

(Facing page) **Fig. 57.**

David Einstein, *Light Echo*, 1975. Acrylic on canvas. 60 x 48". Photograph by Balthazar Korab; courtesy of the artist.

The Return to the Holocaust

In carving out a sense of personal and group identity, Jewish American painters have gravitated in escalating numbers since the end of the 1960s toward the Holocaust as a cultural referent. The Holocaust came to serve as a cornerstone of reflection on issues of Jewish history and memory. By the 1980s, most Jewish artists were addressing it; many responded to it in the manner pioneered by Ben-Zion and followed by Golub, offering material that is both representational and visceral enough for there to be no question as to what has inspired it.

Marty Kalb and Jerome Witkin

Marty Kalb's acrylic paintings and charcoal drawings exemplify this.[7] So do the enormous polyptychs of Jerome Witkin (b. 1939). His *The Butcher's Helper, 1941–45* (1991; 29 feet across) combines details that are almost photo-realist in quality with stretches of deliberately sketchy brushwork (fig. 59). The combination recalls some of Rivers's work, but with a more specific and strident emotional quality. It is anguish, not irony, that we feel as we have burst in like the American GIs on the canvas upon bodies hanging and disfigured or dismembered. It is not merely as if the artist has allowed expressionist emotion to overwhelm the intellective cool of dispassionate observation in combining perfectly finished with

sketchy elements, but as if completion would somehow validate the horror. The incompleteness, underscored by its proximity to perfectly rendered detail, forces upon the viewer the reminder of what a paradox we are as a species: so complete in some respects, so incomplete in others; so magnificent in artistic and other accomplishments, so horrific in the cruelties we can mete out against the world and each other.

There is another twist to this: Witkin's father is Jewish; his Catholic mother raised him as a devout Christian. His admitted obsession with a subject that offers the ultimate negative historical meeting point between Judaism and Christianity is in large part a reflection of the paradoxic confrontation of historical selves that defines his own identity. For us this also further turns the issue of defining "Jewish" in the layered contexts of the discussion of art.

Elyse Klaidman

Elyse Klaidman's works show an intensity similar to Witkin's. Born in New York City in 1960, she grew up in Washington, D.C., in an environment in which she felt little connection either to Jewish matters generally or to the Holocaust. But in 1989, together with her mother, brother, and American-born father, she visited Slovakia and the farmhouse where, as small children, her mother and uncle together with her grandparents had been hidden in the last years of the war. She found herself charged with a new focus, which poured directly into the painfully specific visual self-expression that now began to define her art. The paintings done after that year were portraits of *Distant Relations*, relatives destroyed by, or who survived in spite of, the Nazis. Based on family photographs that had little meaning for her before, these haunting faces from the past loom large in the timeless present of her canvases. *The Sisters* immortalizes Elyse's mother's two cousins, taken to Auschwitz at age twelve and fifteen (fig. 60). The younger died there; the older survived because she was close enough to womanhood for an SS officer to pull her from the gas chamber line, saying, "You're too beautiful to die." The eyes of both sisters are deep, dark, and intense. There is irony to the spring-green color of their dresses that militates against the dark blood-like red that the artist has allowed to drip freely down the canvas.

We also recognize a particular continuity between the interest in Christ's earthly fate explored by earlier Jewish artists and paintings in Klaidman's *Crucifixion* series. Again and again we find colors that we recognize: the purgatorial combination of dripping red and black, punctuated by patches of spring green. Sometimes the lurid yellow is there that has been associated over the centuries in Western, Christian art, with Judas, which was so precisely picked up by that failed

Fig. 59.

Jerome Witkin, *The Butcher's Helper,
1941–45*, 1991. Courtesy Jack Rut-
berg Gallery, Los Angeles, CA.

100

artist, Hitler, in imposing the yellow star on his Jewish victims. Conversely, Klaidman often weaves the suggestion of a Star of David into the cruciform elements of her compositions.[8]

Kitty Klaidman

Elyse is the daughter of a survivor whose work as an artist also turned toward the Holocaust in 1989, after the journey home to Slovakia. For the five years following that excursion into and confrontation with a long-buried part of her past, Kitty Klaidman's (b. 1937) painting became an exploration and perhaps an exorcism of what had been buried for forty-four years. But it is a calmer exorcism than one might expect. Works like those in her 1991 *Hidden Memories* series are golden-brown, monochromatic color fields, crossed by diagonal and horizontal lines (fig. 61). The re-vision of the attic crawl space where her family was concealed becomes not only filled with a kind of light blue light, but as the series develops, becomes more and more a study of contrastive geometries and colors, rather than the beams and joists that actually defined that world of two years of her early childhood. Indeed it is only by the subtitles *The Attic*, *The Ladder*, *The Trapdoor*, *Crawlspace* and by our knowledge of Kitty's life story that we understand their hidden meaning.

Such works fall on the border between the representational and the abstract as they sit between pain and healing. In 1992, both processes had shifted further.

(Facing page) **Fig. 60.**

Elyse Klaidman, *The Sisters*, 1991. Courtesy of Elyse Klaidman.

Fig. 61.

Kitty Klaidman, *Hidden Memories: The Attic*, 1991. Courtesy of the artist.

Fig. 62.

Kitty Klaidman, *The Past Purged: Abstracting Memory II*, 1992. Courtesy of the artist.

The Past Purged: Abstracting Memory series completes the restructuring of hidden memories into ordered geometries (fig. 62). Color has deepened, line has sharpened, so that, without the narrative, we might see these simply as further twists to the visual explorations of Noland and LeWitt. Most interestingly, the older Klaidman's work offers a striking contrast to that of her daughter, revealing a pattern that seems to repeat itself frequently in distinguishing survivor artists from second generation artists. The softer work of the mother serves as an instrument of resolution, a healing, whereas that of the daughter expresses her anger at horrors she could not prevent.

Sherry Zvares Sanabria and Janis Goodman

A similar calm speaks from Sherry Zvares Sanabria's (b. 1937) large, still, photorealist images, recalling Joseph Solman's eloquent paintings, but depicting empty buildings and silent rooms at sites such as Dachau and Matthausen, half a century after the events that marked them (fig. 63).[9] As the number of Jewish artists addressing the Holocaust has expanded, so has the range of vocabulary, not only with respect to style but in terms of symbols. We have noted R. B. Kitaj's use of the chimney as a symbol in Jewish art *at large*. For others, other symbols have offered that same sort of resonance. Railroad tracks are one obvious example. Sometimes, as in the works of Alice Lok Cahana, they lead ladder-like upward (but to nowhere except the oblivion beyond the canvas), or converge to a vanishing point deep within the picture plane, as in works such as Anselm Kiefer's *ZimZum* or simply repeat themselves in abstract patterns, as in the work of Sherry Karver or Judith Liberman.[10] Suitcases, piled up or in spaceless isolation, connote the Jewish experience of *aloneness*—suitcase in hand on the railroad platform to

Fig. 63.

Sherry Zvares Sanabria, *Hallway (Mauthausen)*, 1992. Acrylic on museum board. 32 x 40". Courtesy of the artist. Photograph by Joel Breger.

the concentration camp—joined to the universal idea of aloneness experienced by *any* traveler in an alien setting. This absolute solitude is present in the sculptures of Michael Katz (b. 1943), who piles suitcases near stiff, attenuated figures and sometimes near a stretch of real railroad track, and in the paintings of Janis Goodman (b. 1951). Goodman's suitcases speak with an eloquent silence (fig. 64). They take on a quality of subject and not just object—an opposite reflection of the condition of those who packed their suitcases for their final journey, who were reduced to objects by their killers.[11] At the same time, their contexts are simply those of loneliness and in particular the loneliness of travelers. Moreover, a startling contrast between the graphite, black and white image and its "frame," alive with floral motifs in egg tempera color, helps to underscore the deathlike silence of the internal image.

Selma Waldman

Many Jewish artists have used the Holocaust, as Golub did, as a stepping-off point for a broader visual discussion of human violence and brutality and the need for *tikkun*. For example, Selma Waldman's (b. 1931) grim, superbly executed drawings—reminiscent of the work of Rembrandt and Kaethe Koelwitz—connect the hungers and horrors of the Terezin concentration camp to ongoing acts of human inhumanity in our own time. The intensity of Waldman's social concerns is matched by the ferocity of her gestural imagery. Figures billow up like pillars of smoke from the fires of human cruelty and suffering. Emaciated figures from her *Terezin* series (1980s) connect to those in her *Killing Fields* series (1992) by the raw pathos of her line and the eloquence of her chiaroscuro. No line separates yesterday's Czechoslovakia from today's Bosnia. A starving figure clutches a brick of bread, alone. Another shares it. Gaunt figures with hollow, questioning eyes stare out at us. A soldier raises his rifle toward a fleeing mother and child. In *Rubber Bullet*, the concentration camp world of Blacks in pre-Mandela South Africa speak through the mother and child whom Waldman depicts: a bruised and battered Madonna, for whom sacrifice will yield no redemption save that of persistent courage and pride (fig. 65). Such a work asks where the Christian God of Mercy is in all of this suffering—and where *humans* are. For humans create Hell on Earth for humans, and fifty years after Terezin our species has still not learned how to prevent Terezins.

Joyce Ellen Weinstein

The social realist sensibilities that define painters such as Soyer and particularly Shahn and Levine simply but emphatically resurfaced in the context of the sociopolitical issues of the 1980s and 1990s. Joyce Ellen Weinstein's focus, on the difficulties in our world that require repair, is close to home. The raw emotional process with which she shapes Soutine-like self-portraits compels our own emotions to respond.[12] Explosions of lip, eye, nose, and chin reflect a dynamically disturbed reflection on the world internalized by the artist, eternalized onto the canvas, and finally internalized by the viewer.

Every artist's world begins from the question: "what *am* I?" For Weinstein (b. 1940), the answer includes being a woman, a Jew, a member of humanity—and an observer of all of those aspects of the world that comprise her being. One of the most compelling of these is the predominantly African American high school where she taught for six years, and where any of the students to whom she became emotionally connected might not make it through school alive. Wein-

(Facing page) **Fig. 64.**

Janis Goodman, *The Lost Hours*, 1992. Egg tempera and graphite on wood panel. 60" x 48". Private collection, Amsterdam, the Netherlands.

Fig. 65.

Selma Waldman, *Rubber Bullet*,
1991. Charcoal, pastel. 25 x 38".
Collection of Palestinian Ministry of
Refugees, Amman, Jordan.

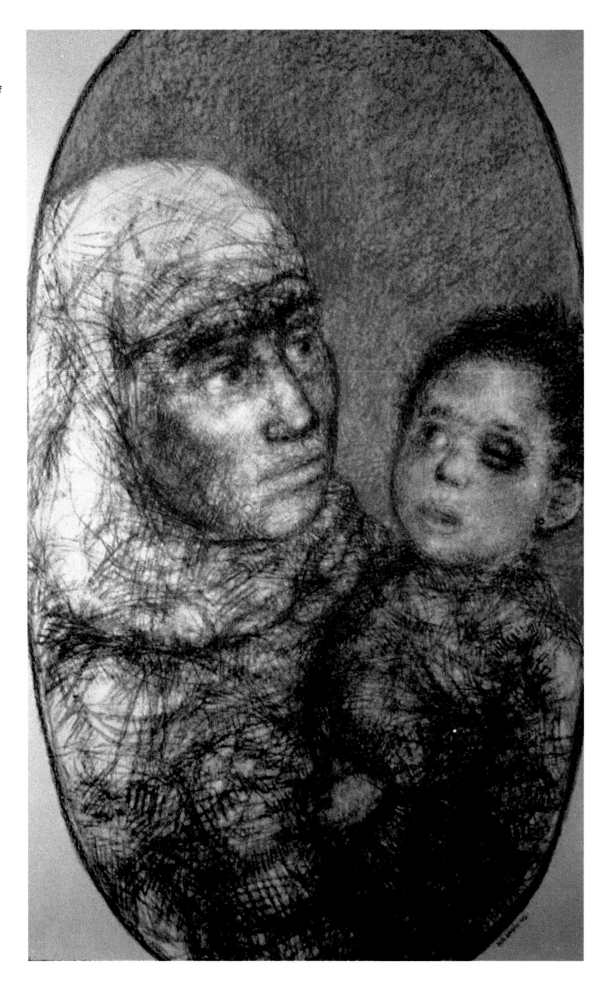

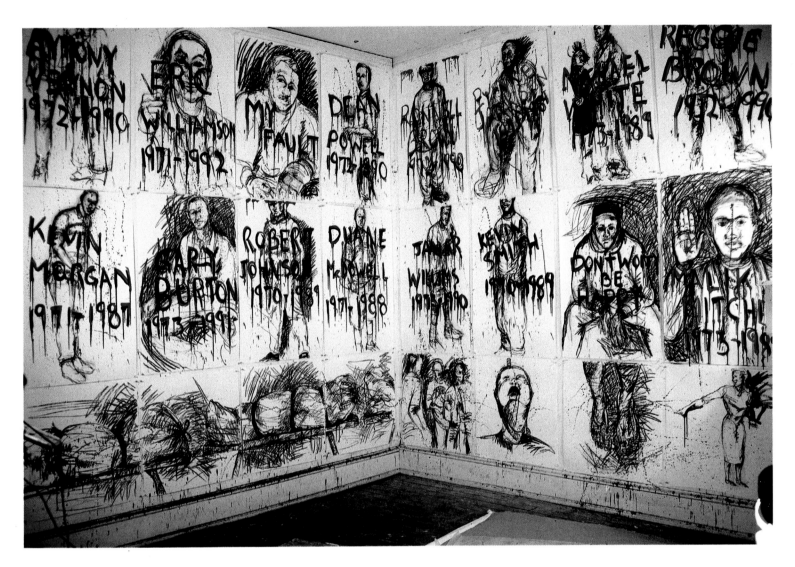

stein began a series that memorialized *The Dead Boys* in 1988, continuing to work on it through the mid-1990s (fig. 66). "As I watched the community of youngsters disintegrate around me—twelve of my students were murdered during my six-year tenure—I became more aware of the need for community and of how this community acts like a glue to hold its members together . . . [This] brought me to a deeper understanding . . . of my own community as a Jew."[13]

For this series, Weinstein produced sixteen portraits and eight smaller details in charcoal and dripping red oil paint on paper. The colors of purgatory—but leading to no salvation—the colors of death and blood, offer Malcolm, Kevin, Robert, Dean, and the others. Their names and the dates of their births and deaths—none older than twenty-one years of age—tell a story that requires no elaborate details to understand: Their blood cries out to society's too-deaf ears.

Similar exercises in societal commentary through distortive power emanate from portraits of Weinstein's friends, as well as from her play on a recurrent theme in Western art: the *Odalisque* (fig. 67). This motif—an alluring nude female stretched out along a settee—has been explored variously by artists from Titian

Fig. 66.

Joyce Ellen Weinstein, *The Dead Boys* (detail), 1990. Charcoal, paint on paper. 200 x 210". Courtesy of the artist.

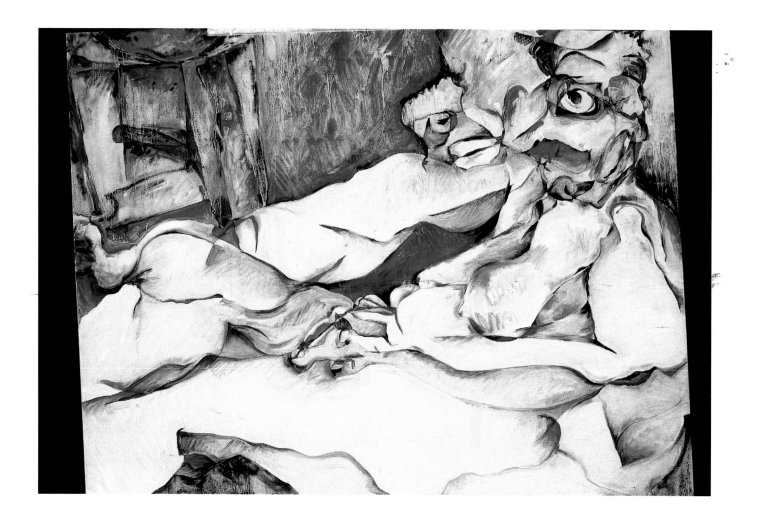

Fig. 67.

Joyce Ellen Weinstein, *Odalisque*, 1996. Oil on canvas. 36 x 44". Courtesy of the artist.

to Pearlstein. Weinstein utilizes the expressionist distortionist technique found in her portraits to turn a woman into an alien, an almost amphibious being who stares back at us with enormous eyes. The women ogled by generations of male artists and their patrons have suddenly converged and been twisted into a being of tormented calm who ogles *us*.

An Explosion of Women Artists

One must be struck by how many of the artists we have been discussing are women. If the first part of the century was marked by an explosion of productivity by Jewish visual artists, then the last quarter of the century has been particularly marked by a Jewish female artistic presence.

Ruth Gikow

Ukraine-born Ruth Gikow's focus on social and cultural issues leads from the social realism of Raphael Soyer, with whom she studied at age nineteen, through

the world of Jack Levine and World War II—she married Jack just after the war—to the varied issues of identity and protest that defined the sixties. By that time, Gikow's style had assumed a distinctive vigor and simplicity of line and delicate tonality. Perhaps one feels the influence of Levine in the shift towards staccato brushwork and a paler patina than in her earlier painting, and the increasingly frequent use of whites to create a semi-translucent, gossamer effect. If Levine became famous for his depictions of the fat-cats, Gikow (1915–1982) depicted those whom the fat-cats devour, in particular city children, whose dark wisdom she portrays with a Soyer-like sensibility. Her *Elevator Girl* (1967), for example, is both a figure drained and a darkly wise child (fig. 68). She is an ignored fixture like the box itself that conveys one up and down, and a child with the weight of adult seriousness already upon her. She wears the uniform of her profession; its ostensive purpose, in standardizing the garb, is to professionalize, but its practical consequence is to distance her from us, her passengers, by making it easier for her to appear as part of the furnishings of the conveyance, rather than as an individual with a personality and a life.

A similar sensibility invests Gikow's *Yeshiva Boy* (1965). The dark-eyed creature recalls the Hebrew-language poet Bialek's verbal portrait of the young scholar struggling with the obligation to rise at dawn and hurry to the House of Study, eschewing the sweet smells and sights of spring that obstruct his way. Gikow's wraith of continuous tradition has paused between us viewers and the dangling chickens of the kosher butcher shop, to meditate, perhaps, on the place of the spirit in a world preoccupied with flesh. His distant cousins—although neither he nor they are aware of that—are the young people in *Balloons* (1968), troubled and fruitless protesters against the slaughter in Vietnam (fig. 69). In a 1969 version, thirteen dark spheres float hopefully upward into space, corresponding in number to the bright faces below, their questions going unanswered as some of them extend youthful arms and hands above the horizon of figures, like the desperate upstretched arms of drowning swimmers.[14]

Susan Schwalb

Susan Schwalb (b. 1944) implies that different ongoing question—of "Jewish art" within in a non-Jewish world—in her series of triptychs called *Creation*. These relatively small works can either hang on a wall or rest on a surface and offer completely abstract compositions inspired by the opening images in the most famous of medieval Jewish illuminated manuscripts, the fourteenth-century *Sarajevo Haggadah*. Her technique revives the Renaissance penchant for silverpoint and copperpoint and weds it to the medieval use of gold leaf. *Creation XX* (1990) pre-

Fig. 68.

Ruth Gikow, *Elevator Girl*, 1967. 24 x 16". Courtesy of Susanna Levine Fisher.

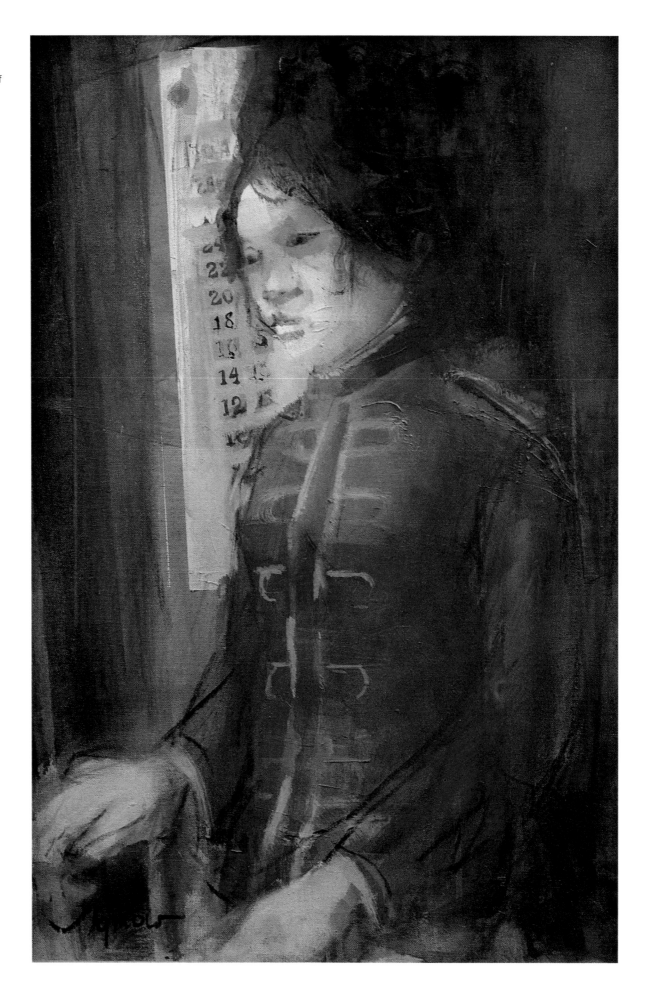

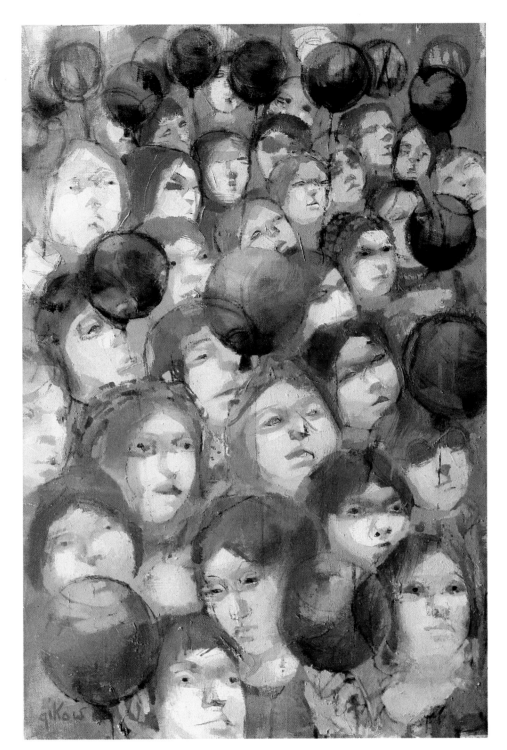

Fig. 69.

Ruth Gikow, *Balloons*, 1968. 39 x 20".
Courtesy of Susanna Levine Fisher.

sents six circles swirling in silverpoint against an earth-brown background in its lower register, which is separated from the sky blue background above by a white goldleaf frame (fig. 70). In the upper register, a circle identical to those below, except significantly larger, is embedded. Creation has been re-visioned in the abstract geometry of the circle (without beginning and without end). The artist has redefined that most Christian form of visual self-expression, with its triune symbolism, in Jewish terms: the general terms of non-figuration and the specific historical terms of the *Sarajevo Haggadah*. "When I first came across the *Sarajevo*

Fig. 70.

Susan Schwalb, *Creation XX*, 1988. Silverpoint, acrylic, gold and silver leaf on wood. 16 x 22 x 6. Collection: B'nai B'rith Klutznick National Jewish Museum, Washington, D.C.

Haggadah I was powerfully stirred to find images of arc and circle . . . Unlike familiar Christian portrayals of the creation, the image of God is not represented. But sun, moon and earth are clearly rendered by circular forms" she wrote in 1993.[15]

Certain of Schwalb's works, such as *Beginnings* (1988), add to the arc-circle configuration a downward-pointing triangle with vertical line from mid-base to apex. This symbol of femaleness is traceable back to Neolithic art. The role of artistic creatrix so long suppressed for women is restored in the very textures of the silverpoint surface she works. Thousands of fine lines engender an active energy—flesh-like, water-like, sky-like—within the static confines of the framing forms. The watery, wave-like lines of the silverpoint surface within the tumescent frame, recall the verbal images of *Ti'amat*, primordial water/dragon/mother goddess of Mesopotamian religion, and her linguistic cognate *T'hom*, watery depths over which the spirit of God swoops in Genesis 1:2. It suggests the amniotic fluid of the womb that connects the birth of humans to the birth of the universe.

The ideal, perfectly formed worlds of Schwalb's materials offer the accomplishment of the artist as individual, as Jew, and as woman. If paintings like those in Weinstein's *Odalisque* series may be viewed as feminist, Schwalb's *Creation* series is sometimes *Jewish* feminist. Indeed, given the patriarchal history of Judaism, and the many levels at which even today women remain excluded from Jewish ritual and celebration within traditional Orthodox Judaism, it should not surprise us that, among the issues raised by Jewish American women artists in the last few decades has been the question "Where do I as a female artist fit into *Judaism* and the images that are part of *Judaism's* history?" Scores of American women artists since the early 1980s have wrestled with the question of where and how, as women, they fit into the Jewish tradition. Some, like Helene Aylon and Carol Hamoy, have created installations in the 1990s, rather than paintings or sculptures.[16] Often Torah scrolls, prayerbooks, and *tallitot*, the material *elementa* of Jewish spirituality, are used and transformed in their work. Many have contributed to the development of a new ritual object, the Miriam Goblet, which reintroduces the sister of Moses and Aaron to the Passover Seder table, side-by-side with the Cup of Elijah.

Marilyn Cohen

Differently, Marilyn Cohen (b. 1938) has focused on the history of Jews in America and, as a separate matter, on the disenfranchisement of women in America (rather than on the disenfranchisement of women within Judaism). In one series of collage-paintings—*Where Did They Go When They Came to America?* (1989–1994)—she presents the stories of one Jewish family in each of the fifty states. *Star of Local Kids*, for example, depicts Bennie Kaplan, eleven-year-old MVP of his 1923 Memphis, Tennessee, Junior Baseball Team (fig. 71). His father Shlomo Zalman Kalmonovsky had arrived in 1902 to these shores and was followed five years later by his wife Rieva and their five young children.[17] Three more were born in Memphis; Bennie was the last.[18] The parents spill, ghostlike and old-world-looking, from the star-spangled upper corner of the canvas-as-flag. Before them stands the proud eleven-year-old wearing the baseball uniform he used to wear hidden under his Sabbath clothes and the catcher's mitt he won as MVP. Who could be more all-American than he—with his Eastern European face?[19]

In a second series completed in 1997 called *Teach Me the Songs My Mothers Sang to Me*, Cohen depicts an array of women who have defined myriad aspects of the American past. Eighteen of them, each in her own frame, have had a major impact on aspects of twentieth century life not often associated with women, including aviation and baseball, and have remained obscured by the shadows of

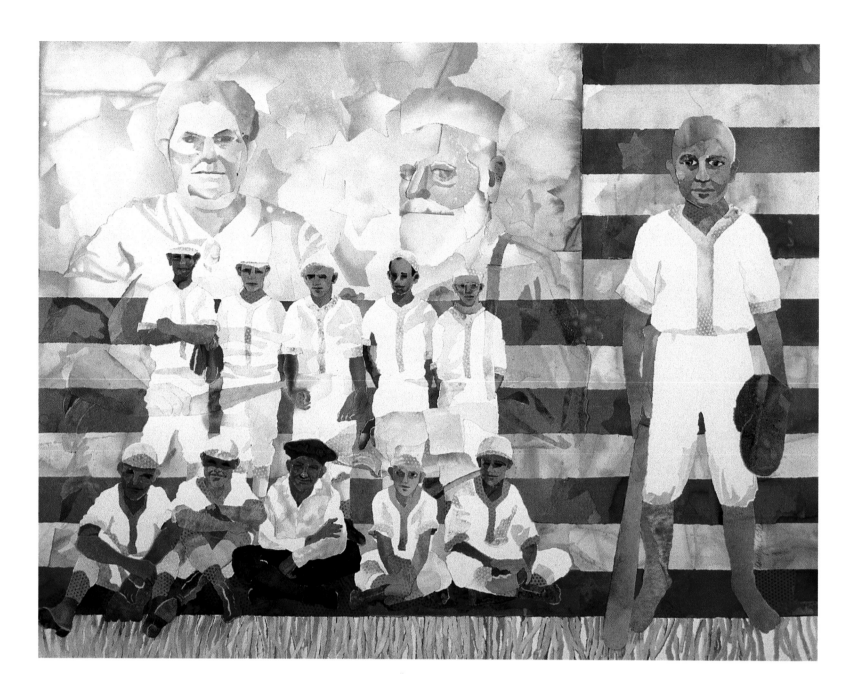

Fig. 71.

Marilyn Cohen, *Star of Local Kids*, 1990. Collage. © Marilyn Cohen 1991.

male counterparts. Complementing these works, a large triptych called *Tea Party* depicts others who are well-known, such as Isadora Duncan and Susan B. Anthony, drawn from across American history. But these are shown stiffly as icons, not as the *people* they were who lived real lives. Indeed, fictional characters like Nancy Drew and Dorothy from *The Wizard of Oz* and Wonder Woman are dispersed among them. As in *Where Did They Go When They Came to America?* in *Teach Me the Songs My Mothers Sang to Me*, the geography and history of America are torn apart and reconstructed, the elements of time and memory layered literally by Cohen's virtuoso painting-collage technique.

Ruth Mordecai

Significant portions of Ruth Mordecai's work often reflect ideas that are visually Greek and spiritually Jewish. Mordecai's early turn to the human torso in sculpture and drawing as a meeting point between varied contrapuntal rhythms—stasis and motion, tensed and relaxed elements, bunching and extension, those washed by light and those buried in shadow, rectilinear and curvilinear—connects to architecture (particularly in Greek thought). The ultimate curve, defined by the surging right side of the body from leg to shoulder as it turns toward the left, is an arched form, as if the casements of doorways and arched surmountings have been turned sideways and at angles. Her drawings, collages, and sculptures of 1985–1987 are variously gigantic and small in scale, as they shift from the twisting torso to the swooping arch.

But interestingly, Mordecai (b. 1938) instinctively sensed a connection between the arched form with which she was obsessed and a specific context of Jewish sacrality. She became aware, in the mid-eighties, of the important role of the arched form in the architecture of the early synagogue: the Syrian Gable over the main doorway of structures such as that at *Kfar Nahum* (Capernaum) and *Kfar Bar Am*. Personal preoccupation thus relates, for Mordecai, to universal architectural principle across the bridge of a specific aspect of the Jewish visual past. Expressed among other places in her *Arch Series: Sacred Place*, that sensibility would carry into the 1990s and an *Altar* series of monoprints and sculptures, which, together with her *Seven Series* (1990), offers the sort of large scale, simultaneously celebratory and reflective abstract chromaticism that charts a deliberate course of connection with the work of Newman, Rothko, Gottlieb, and Guston (fig. 72).[20] The need to restore order to the world—*tikkun olam*—echoes not only these artists' sensibilities in the aftermath of the Holocaust, but in Mordecai's work, the ongoing post-Holocaust moral chaos of Cambodia, Rwanda, Bosnia, and elsewhere.[21]

Fixing and Blurring Boundaries

Leonard Baskin

Continuity contends with change; issues repeat themselves in new forms as we move from one end of the century to the other. The Jewish presence in American visual art crosses the borders between media as well as style and subject, often in the work of one artist. Leonard Baskin (1922–2000) devised a handsome Hag-

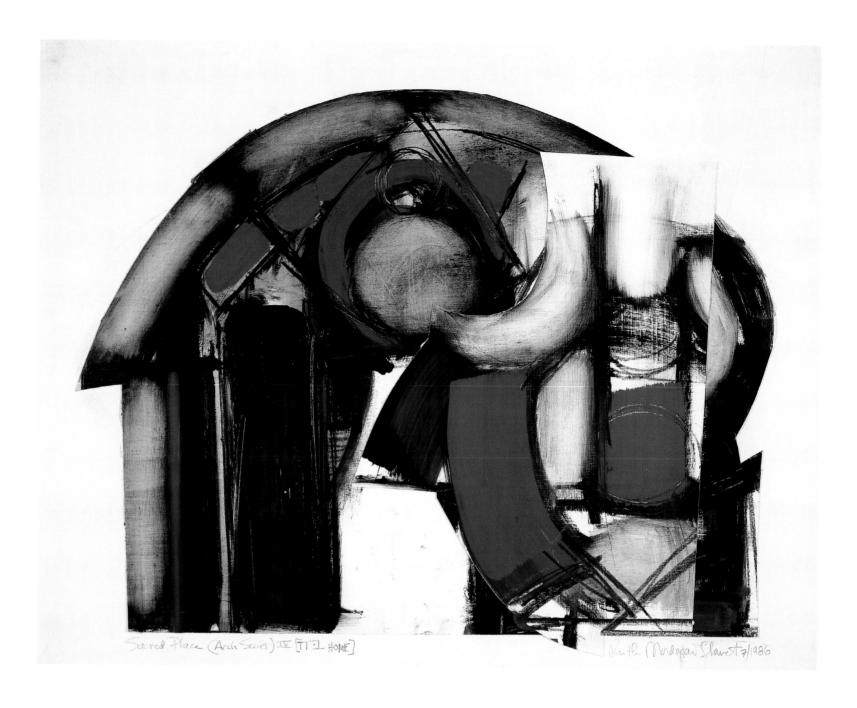

Sacred Place (Arch Series) IV [בית HOME] Ruth Mordecai Slavet 7/1986

Fig. 72.

Ruth Mordecai, *Arch Series IV: Sacred Place*, 1987. Collage, oil. 25 x 31". Courtesy of the artist.

gadah in the tradition of Ben Shahn and Arthur Szyk, and became particularly well known for producing an array of exquisitely made books at his own small press. But Baskin is also noted for his visual expression of a broad interest in peoples and ideas. One of his last series of lithographic works focused on Native American chiefs (fig. 73). He conveys both their nobility and the suffering that five centuries of cultural and physical decimation has wrought on the tribes they represent, some of them now gone, others reduced but seeking to re-assert their own cultural identities. There is perhaps more than accidental irony to the fact that that process began, in retrospect, in the same year—1492—that would have such dire consequences for the history of diasporatic Jewry, including the start of the process that would eventually bring Jews in such large numbers to the shores

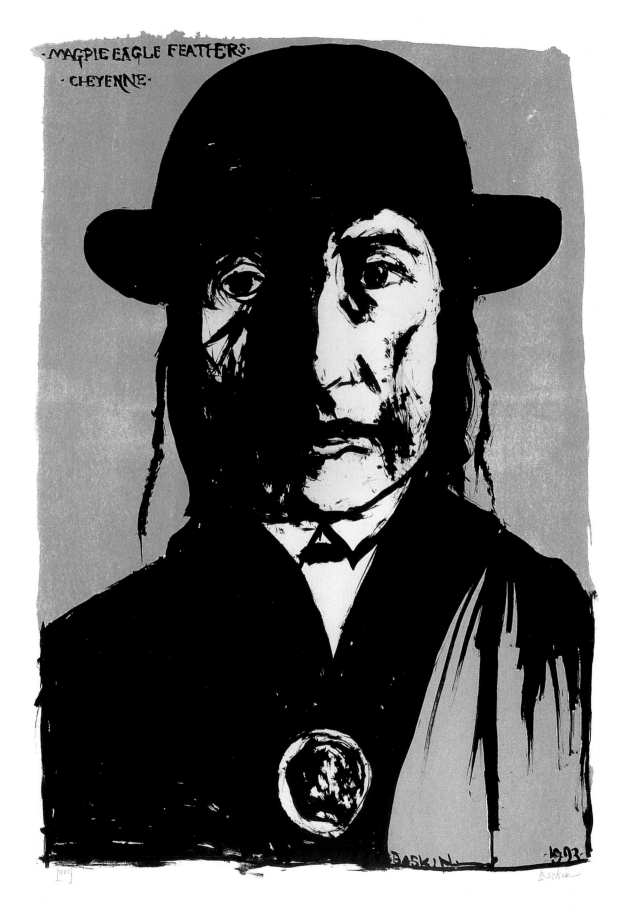

Fig. 73.

Leonard Baskin, *Magpie Eagle Feathers*, from *Native Americans, The Second Series*, 1993. Lithograph. 42 x 30. Courtesy of Gehenna Prints

of America. But Baskin would not necessarily assert a connection between his Jewish (social and other) consciousness and these works.

Tobi Kahn

Tobi Kahn (b. 1952) stands even more emphatically at that intermedia boundary. It has only been since his significant success as an abstract painter—in which he explicitly charts spiritual territory akin to that of Rothko and Newman—that his unique shaping of new Jewish ritual objects has attracted serious interest.[22] In his paintings since the early 1980s, light—which marks the beginning of the universal order in Genesis—is dominant, shaping landscape into a mirror of memory and imagination as landscape. Archetypal forms and suggestive shapes such as rocks, horizons, water, electron micrographic biomorphs, are hinted at, in a luminous, lushly textured format that enhances a sense of the transcendent, and in

Fig. 74.

Tobi Kahn, *Madai*, 1995. Acrylic on canvas over wood. 72" x 48" x 2½". Collection of Museum of Fine Arts, Houston, Gift of Jane Blaffer Owen.

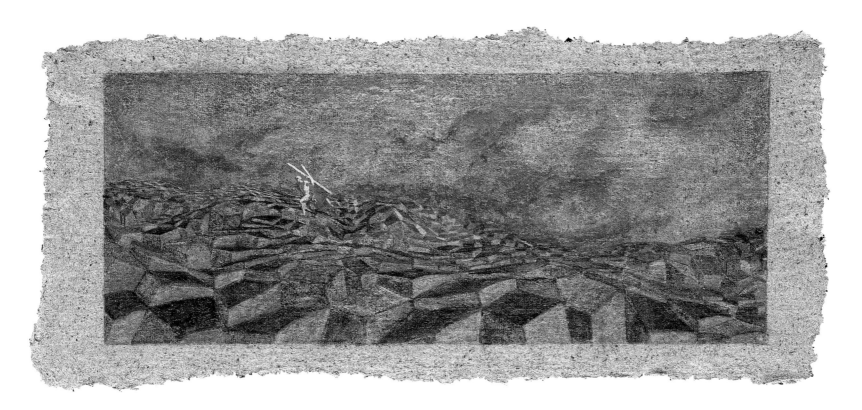

Fig. 75.

Rose-Lynn Fisher, *Doorway*, 1995.
Mixed media with acrylic and copper
leaf on paper. 15 x 34". Courtesy of
Maxine A. Cummings, Los Angeles, CA.

which macrocosmic and microcosmic landscapes are interwoven with those provided by the mind (fig. 74).[23]

Rose-Lynn Fisher

Rose-Lynn Fisher (b. 1955) stands at several borders. She is both photographer and painter. As a painter, Fisher often combines different media as well as figurative with abstract elements. Her work plays with Renaissance imagery and with the Albertian illusion that one looks at a painting as if through a window into space filled by volumetric figures and objects, rather than at lines and colors on a flat surface. Again and again her landscapes become topsy-turvy exercises in rectilinear perspectival geometries, recalling Sol LeWitt's *Wall Drawings*. Her work *Doorway* (1995), for example, offers a hilly realm of Rubix cube–like patterns across which a figure moves carrying a pair of doors, so-configured to resemble a St. Andrew's cross: The figure struggles at the horizon with his burden across a Golgothean landscape (fig. 75). He is what he bears: a doorway. He is the meeting of spiritual and aesthetic realms.

Besides black and white, the only color used in this landscape marks the whole cloudy sky that fills precisely the upper half of the picture plane. It is a burnt orange shade, copper leaf, almost sepia in tone as if to underscore the allusion to an earlier era of Western art history. "The metaphor of threshold is the thread of constancy in my work. As a point of entry and departure between the

known and the unknown, a threshold is the internal structure of spatial, temporal, and spiritual transition," Fisher wrote in late 1999. "Here the sacred meets the mundane, the absurd joins the poignant . . . a vanishing point becomes visible . . . Patterns in perspective create distance; patterns in time create tradition."[24] Fisher's fascination with "otherness" in time, space, experience—*being*—places her constantly at the boundary between the selves that define her: artist, woman, Jew, American, Los Angelina.[25]

Geraldine Fiskus

Among the most important boundary markers between realms in the Jewish tradition are gravestones. They are not only the gateway between the living and the dead, but between the present and the past. Not surprisingly, among the most interesting places where Jewish visual self-expression has been exercised are the old Jewish cemeteries of Eastern Europe, many of them decimated during or since the Holocaust. "Through metaphor they reveal family and religious values which were the locus of community life. As reinventions," the paintings of Geraldine Fiskus (b. 1943) of details from gravestones or of groups of entire stones "continue the Yiddish culture which ended with the Holocaust," the artist has written.[26]

Fiskus' series, *Reinventing the Visual Language of Jewish Stelae of Eastern Europe*, is of particular interest for several reasons beyond its intrinsic aesthetic merit and her unusual method of underpainting not with white gesso but with black, lending a dark luminosity to her paintings. The series came, in the mid-1990s, on the heels of a decade-long *Alternative Icon* series, in which she juxtaposed figures from popular culture and art history with architectural elements; thus it continues the issues associated both with that aspect of pop art begun by Larry Rivers and with an array of Jewish artists reinventing Western art within its traditional, largely Christianate context. They also return her—and us—to the discussion that dominated her childhood: the Holocaust. "My life view was formed in this context; punctuated by a profound sense of losing a world which I actually never had." This sense of Holocaust-related loss is an emphatic element of her larger works, such as *Stele IV: Birds and Fallen Branches*, or *Stele VI: Fallen Limbs*, in which "the cut limbs resonate the forced separation of Jewish families; the transports of young children taken from their mothers to the death camps" (fig. 76).[27] The tree of Jewish life is not uprooted, just truncated; it *can* continue to grow, but in which directions?

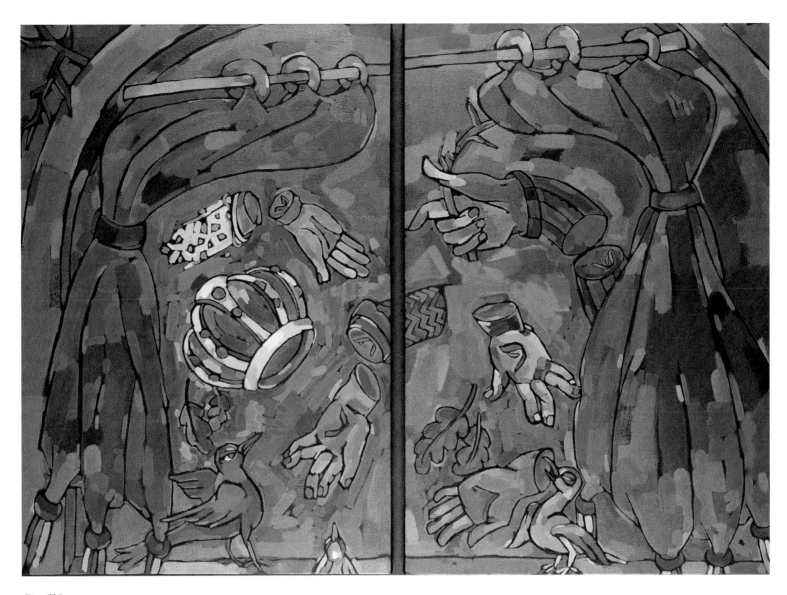

Geoff Laurence

Geoff Laurence (b. 1949) carries it in a singular direction. "Nearly all my relatives on both sides perished in the mountains of ash of the concentrations camps of Europe," he wrote in late 1999. Like Fiskus and Elyse Klaidman, he turns us back toward the Holocaust as a highly personalized event that, although "second-hand," cannot be avoided. But unlike these artists, in his childhood he "was told that I was *not* Jewish. My father . . . was vehemently anti-Semitic and refused to answer the obvious questions that occurred to me about his background. . . . I was told not to emulate 'Jewish' traits . . . [Through my painting] I have embarked on a journey to find out exactly what being 'Jewish' means for me. Perhaps the Holocaust informs everything that I paint. How could it not?"[28] The artist grew up with contradiction and identity confusion as part of his essence. Laurence's triptych *T'fillin* encompasses both the inside and the outside of interwoven issues (fig. 77). The relationship between a Jewish artist and the triptych form has already

Fig. 76.

Geraldine Fiskus, *Jewish Stele VI: Fallen Limbs*, detail from the series *Reinventing the Visual Language of Jewish Stelae of Eastern Europe*, 1997. Oil on canvas. Two panels, 46" x 32" each. Courtesy of the artist.

Fig. 77.

Geoff Laurence, *T'fillin* (triptych), 1999. Acrylic on wood. 46 x 22/34/ 22 (all three panels together). Courtesy of Van de Griff Gallery, Santa Fe, New Mexico.

received comment several times; Laurence turns the traditional horizontal configuration into an uneven vertical one. His hyper-realist style—there is no doubt as to what the eye sees—offers three views of the disconnected body of a luminous naked female. The leather thongs of the phylacteries are wrapped variously around belly, arm, and breast. The woman as object, from Giorgione to Hugh Heffner; the place of women (who are not traditionally permitted to wear phylacteries in Jewish ritual); the place of "Jewish" art within Western and Christian art; and the place of Jews within the Christian world (an evolving but continuous bondage, whether in ghettos of the body or the mind)—these are all bound together by those thongs, enhanced by the astonishing and very contemporary visual pun on the relationship between leather and sexual objectification.

Elaine Kurtz and Michael H. Goldman

How utterly different all this is from the *Alluvial Paintings* series (1995–2000) of Elaine Kurtz (b. 1928)! Her works, contrived of paint mixed with sand, minerals, and pebbles poured and dispersed over the canvas, create crusty ridges and mounds (fig. 78). They are at once entirely abstract and suggestive of formations in nature. Their mysterious, misty quality recalls nineteenth-century Romanticism, while the process of pouring onto the floor-bound canvas and rotating it to assert some control over the shapes formed upon it recalls Helen Frankenthaler's work, and in turn, Jackson Pollock's. But where Frankenthaler offered pigment thinned to the delicacy of watercolor, Kurtz offers a thick, dense, slow-moving compound. Here are river deltas, glacial flows, interior landscapes that are a visual metaphor for the very process of creating them, as they redefine the parameters of painting.

Michael Goldman's paintings are also abstract yet formed directly out of nature. His process begins with photo-like sketches of a landscape that he then reworks repeatedly by magnifying parts of the representational whole until they appear to be pure abstract explorations of color.[29] His bold deconstructions of the subject offer an oblique echo of LeWitt, for they re-vision reality according to the dictates of the mind as much as the eye and brush (fig. 79).

Shaping and Reshaping the Questions

Works that synthesize Rivers' pop irony with internal questions of identity have also emerged in the last few decades. Works that reflect, tongue-in-cheek, on stereotypes regarding noses, nose-jobs, and name-changes; Jewish American prin-

(Facing page) **Fig. 79.**

Michael H. Goldman, *Arizona Series:
Canyon V*, 1991. Oil on canvas. 48" x
36". Courtesy of the artist.

cesses and rampant materialism; physical beauty, finesse, and strength—and icons that further or contradict stereotypes from Barbra Streisand and Bob Dylan to Sandy Koufax—are part of the vocabulary of some Jewish artists in the 1990s.

Deborah Kass

The repeated images, in four colors, of the silkscreen and acrylic *Four Barbras (the Jewish Jackie Series)* (1992) or *Double Red Yentl, Split (My Elvis)* by Deborah Kass (b. 1952), and her enormous, repeating *Sandy Koufax* (1994) are overt homages to Warhol and to mass media (fig. 80). But the homage is subsumed into the issue of identity, for Koufax contradicts the nonphysical image of the Jew, recalling the call at the turn of the century among shapers of the Zionist idea, for "muscular Judaism." And equating Streisand with Jackie Kennedy suggests the one as a Jewish equivalent of the virtual royalty defining the other in the pop American consciousness. The overt allusion to Warhol also suggests an intended analogy with Warhol's most famous offering of an American icon: Marilyn Monroe.

Adam Rolston

The six-foot-square canvas painted with synthetic polymer, entitled *Untitled (Manishewitz American Matzos)* (1993) by Adam Rolston (b. 1962), is part of a series that also recalls Warhol's Campbell's Soup can as it turns toward the issue of ethnic-, racial-, and religious-targeted advertising and packaging. In contrast to the smooth textureless quality of a Warhol silkscreen, though, Rolston's paintbrush leaves the evidence of its textured presence to mirror the absence of substance in the holiday and its rituals. For assimilationist Jews, Passover has become the colorful commercial box of *matzah* that, as they consume leavened bread alongside it throughout the week-long Festival of Freedom, is the only vestige of the three-hour-long Seder they recall from childhood but have significantly reduced or altogether abandoned.

Even as many young Jews in the late sixties and early seventies turned everywhere but toward Judaism to define themselves in the wide-spread search for roots, by the eighties, as we have seen, many began to turn back to Judaism, but laden with questions. How does someone who doesn't believe in God, or doesn't believe in God's interest in and involvement with us, or doesn't believe that the Torah is simply and in its entirety the word of God, define himself as a Jew? How does one balance the beauty of ritual and its elements (or even the gastronomic elements of the Passover celebration) with the commercialization imposed upon them by manufacturers and advertisers, many of them *Jewish?*[30]

Fig. 80.

Deborah Kass, *Double Red Yentl, Split (My Elvis)*, 1992. Oil on canvas. The Jewish Museum, NY/Art Resource, NY

Andra Ellis

The colorfully painted ceramic reliefs of Andra Ellis (Avigayil Elsner) reflect this issue, in part.[31] Her work emulates Paul Gauguin's ruling principle (derived from Pissarro) of how to express on the canvas the internal, rather than the external world by means of color: "How do you see that tree? Is it green? Then paint it with the greenest green in your palette! Do you see the shadow as blue? Then don't be afraid to paint it as blue as possible!" Gauguin had said.[32] To color, and to line, form, and volume, Elsner (b. 1948) adds the fifth dimension of texture—a burning, blistering, sandy, grainy, gouged texture that recalls Kurtz' assault on the canvas. But Elsner's work is ceramic relief consistently defying its frame. Portrait-like works such as *The Echo* and *Visions: A Loss of Faith and Reason* address the Holocaust and its ramifications for life in our own time. "Many of my pieces probe and document the pain and anguish in the late twentieth century; its sexism, violence, its rampant social inequities. These pieces speak of my fears for my child—for all our children—as we approach the year 2000," she wrote in 1992.[33]

At that time, her *Joyous Journey* series, with its frameless shape and its recurrent boat-like image—a deep blue crescent that also suggests the moon still taking its final shape—could be a commentary on the intent of Rolston's work (fig. 81).

Fig. 81.

Avigayil Elsner (Andra Ellis), *Joyous Journey #3*, 1992. Acrylic and ink on glazed clay canvas. 29" H. x 41" W. x 3" D. Private Collection.

"In moving from New York to Charlotte, North Carolina, I felt as if I were leaving (not to but from) Egypt".[34] In Charlotte, ironically enough, away from the million Jews who inhabit New York City, her own Jewish identity began finally to take shape. Never having participated before in a real, evening-long Passover seder, now she did—one lasting until 3 A.M. Exiled in North Carolina, she found herself for the first time a part of the House of Israel.

Mel Alexenberg

This exploration is different from that of scientist-turned-artist Mel Alexenberg (b. 1935). A Modern Orthodox Jew, Alexenberg consciously articulates the parameters of Jewish art. In commenting in the early 1980s on the image of the *tallit*, the Jewish prayer shawl, and its termination in twisted, precisely configured fringes—spiraling, branching, extending, outflowing terminations—the artist related the images of spiral scrolling and branching both to the natural world, from DNA helix to sea shell, and to Jewish consciousness and visual symbolology: not only the *tallit* fringe, but the leather phylactery thong that spirals the arm in prayer, the unshaved earlock, and the doubly scrolled Torah.

Much of the artist's work includes computer-generated images that also develop as spiral and branching systems: the doubly wound video and audio tape, the branched format of the microchip. Alexenberg appropriates an iconic image from the Christian artistic tradition: Rembrandt's angel, who wrestles with Jacob. But he transforms and distorts it, digitalizing and dismembering it, transforming the normative Western tradition within which he works as he rebels against it. He superimposes that angel—*mal'ach*, in Hebrew—over a Brooklyn street scene dominated by signs for kosher food (fig. 82). And so his image word-plays: food—*Ma'achalah*, angel—*Mal'ach*, art—*Ma'alechet*. The most down-to-earth of elements—food—and the most mysterious of biblical communications from God—angel—are mediated by art.

Osvaldo Romberg

The border between heaven and earth mediated by the text of the Bible is, naturally, a continuous source of visual imagery for Jewish American painters, from Ben-Zion's expressionism in the 1930s to Janet Shafner's mysterious narratives focused on biblical women in the 1990s.[35] Osvaldo Romberg's (b. 1938) paintings often play with the question of "Jewish" art within Western, Christian art through the use of biblical images from Caravaggio. He superimposes details on these images in the form of Hebrew letters, words, and symbols. What was intended

Fig. 82.

Menahem (Mel) Alexenberg, *Famous Angel*, 1987. Acrylic on masonite. 38" x 42". Courtesy of the artist.

as a Christian subject made sensuous by Caravaggio acquires a Jewish secular-mystical patina from Romberg. For instance, the famous image of *David with the Head of Goliath*—renamed by Romberg *Untitled* (1999), is imprinted with long, thin, translucent rectangles of blood red and a rough-hewn schema of the Temple that David's son Solomon would build (because David was told that, as a man of war, he himself could not build it) and that Jewish tradition asserts will be rebuilt in the messianic era (fig. 83). So the Caravaggesque present moment begets the Judaeo-Christian past and the Jewish future, and addresses the timelessness of Jewish thinking. The view back and forth from David the anointed to

the Anointed—the *mashiah*; *christos*; messiah—in the unspecified future defines the redefined picture plane.

Fig. 83.

Osvaldo Romberg, *Untitled*, 1999. Oil on canvas. Collection of Zeev Holtzman, Tel-Aviv.

Jane Logemann

A growing number of artists have addressed specific, deeper aspects of the Jewish tradition, such as mysticism. In part this reflects the intensified spirituality to which both Jews and non-Jews were drawn in increasing numbers as the Christian millennium approached. In part it reflects a deepened, specifically focused search for identity. Jane Logemann's work, for instance, in which pale pigments wash over repeated words or letters, echoes the Jewish mystical principle of

Yit-ga-dal ve-yit-ka-dash she-mei raba be-al-ma di-ve-ra chi-re-u-tei, ve-yam-lich mal-chu-tei be-cha-yei-chon u-ve-yo-mei-chon u-ve-cha-yei de-chol beit Yis-ra-eil, ba-a-ga-la u-vi-ze-man ka-riv, ve-i-me-ru: a-mein. Ye-hei she-mei raba me-va-rach le-a-lam u-le-al-mei al-ma-ya. Yit-ba-rach ve-yish-ta-bach, ve-yit-pa-ar ve-yit-ro-mam ve-yit-na-sei, ve-yit-ha-dar ve-yit-a-leh ve-yit-ha-lal she-mei de-ku-de-sha, be-rich hu, le-ei-la-min kol bi-re-cha-ta ve-shi-ra-ta, tush-be-cha-ta ve-ne-che-ma-ta da-a-mi-ran be-al-ma, ve-i-me-ru: a-mein. Ye-hei she-la-ma raba min she-ma-ya ve-cha-yim a-lei-nu ve-al kol Yis-ra-eil, ve-i-me-ru: a-mein. O-seh sha-lom bi-me-ro-mav, hu ya-a-seh sha-lom alei-nu ve-al Kol Yis-ra-eil, ve-i-me-ru: a-mein.

repeating sounds and words again and again, to the point of trans-sensibility. At the same time, it reflects the kind of purely formal principles—art as simple color and pattern—of work like much of that by Sol LeWitt and also of the mesmerizing sound-repetitions found in the music of minimalist composers such as Phillip Glass, with its graduated nuantial changes. Logemann (b. 1942) often focuses on words that have a Jewish import, as in a ten-part series on the *Kaddish*, the Jewish affirmation of faith *cum* mourner's prayer (fig. 84); or a Jewish/non-Jewish *political* significance, as in *Co-existence*, which she presents in Arabic on one side of the canvas and in Hebrew on the other side. Logemann's work is thus embedded both in the Jewish mystical tradition and in wider, Jewish, secular, and universalist circles.

Archie Rand

Archie Rand (b. 1949) has been referred to as "the major visual interpreter of Jewish text," and achieved renown for a lush and exciting cycle of murals in Brooklyn's B'nai Yosef Sephardic synagogue.[36] In 1998, he completed a series of paintings called *The Eighteen*, in each canvas of which he embedded one of the Eighteen Benedictions that are an essential part of the traditional Jewish prayer book (fig. 85). Careful calligraphy is matched by stunning colors and a successful play between senses of flatness and three-dimensionality. Most significant for our discussion are four particular features of this monumental series. First, there is the significance of tying text and image together, literally wedding the People of the Book to a Peoplehood of the Image. Rand both confirms an essential facet of Jewish identity and contradicts the stereotypical view of a hole in Jewish self-expression. Second, "eighteen" is not only the number of the benedictions, but in the numerology of Hebrew is the symbol of life (since the two letters that spell "life" in Hebrew add up to eighteen). So these works are a meditation, in a profound sense, on Jewish *life*.

Third are the details of the symbolic images that overrun his canvases. He combines elements such as the seven-branched candelabrum (oldest of Jewish symbols in art) and the arched form (the Syrian Gable of the early synagogue) with paired columns that signify the Temple by traditional synecdoche, with Islamic-style geometric and vegetal patterns that bespeak the relationship between the infinite God and our finite world. In this context, the ionic capitals re-assume their original visual derivation: from the form of a ram's horn that, in the Jewish context, carries us all the way back to the covenantal moment on Mt. Moriah when a ram was sacrificed instead of Isaac. Finally, the images are placed throughout the series against the kind of chromaticist background that

(Facing page) **Fig. 84.**

Jane Logemann, *Kaddish* (detail: *Canvas No. 5*), 1995. Ink, oil, varnish on canvas. 31" x 22". Courtesy of the artist.

Fig. 85.

Archie Rand, *Number Fifteen*, from *The Eighteen*, 1994. Acrylic on canvas. 54 x 54". Courtesy of the artist.

recalls the paintings of Mark Rothko. There is irony in the fact that Rand's simultaneously overt Jewish focus and broad modernist aesthetic awareness inspired the *Too Jewish?* exhibition of 1998, by challenging the discomfort with Jewish identity of the curator at New York's Jewish Museum with work that is both Jewish and universal.[37]

Evelyn Eller

Jewish artists have more than occasionally turned to *textuality*, particularly in the past quarter-century. This is expressed even earlier, at times, in the importance of titles. We have observed how Barnett Newman often accorded names to his works that accentuated an intent that would otherwise have been invisible to the viewer, and that might still remain invisible to a viewer unaware of word-specific Jewish issues. And we have seen how texts are found *within* the works themselves, from Rivers to Rand. So, too, the art of the *book* as another vehicle for socio-political commentary has exploded among Jewish American artists. Evelyn Eller (b. 1933), for example, has produced a series of artist books, such as *Defining Woman*, in which the repeating black and white sketch of a woman's face is overrun with an array of dictionary definitions—daughter, wife, goddess, heroine, mother-in-law, witch, widow, womb, barren, care—terms traditionally associated with "images" of what women are and do.

Jenny Tango and Marilyn R. Rosenberg

Jenny Tango (b. 1926) offers a work that presents the matter of Jewish women in a specifically folkloric context. Her *Women of Chelm* reflects on the not-often-mentioned female folk in that quasi-fictional Polish Jewish village (*shtetl*), about which so many tales have been told, reflecting on the delightful wisdom and, above all, the peculiar logic that defines how Chelmites think and operate—usually foolishly. Marilyn R. Rosenberg's (b. 1934) *Istoria Leonardo: What Happened to Leonardo?* is, in a sense, the opposite of that (fig. 86). For she explores the ultimate exemplum of pure intellect, overrunning her sheets of hand-made paper with quotations from the artist-scientist's notebooks, with imagery and sketches and notations and observations. *She* is the notator and observer of the ultimate observer and notator. It is a book about a dyslexic whose words and images are turned upside down and backwards, and about the question of what it means to be different or to do things differently, whether one is a woman, a Jew, a dyslexic, or a Leonardo.

Fig. 86.

Marilyn R. Rosenberg, *Istoria Leonardo: What Happened to Leonardo?* 1991. © Marilyn R. Rosenberg 1991.

Diane Samuels

Words and letters play differently, as colorlessly as in Barnett Newman's *The Name II* in work like that of Diane Samuels (b. 1948). Her *Letter Liturgy (for Leon)* (1993–1999) reflects on an old Hassidic story regarding what God accepts as piety: not book-learned knowledge of the prayer book or the Torah, but the purity of the heart's intention, symbolized by the illiterate Jewish peasant who cannot read the prayers but keeps reciting the Hebrew alphabet, allowing God to combine the letters into words (fig. 87).[38] Samuels plays on the very abstract arbitrariness of letters as symbols that in combination represent words and ideas. Are the "letters" in her "book" *letters*? If not, *is* this a book? Can *non*-letters form the words that comprise prayers? Do prayers require well-wrought words or, for a textual people like Jews, well-shaped letters? With what instruments—words? melodies? gestures? images?—does one most effectively address God? Is God listening and looking—and interested—anymore? What form of "art" uses only letters, white ones against white? Is this "painting," "sculpture," or something else entirely?

And is it mere coincidence that such a plethora of contemporary Jewish

Fig. 87.

Diane Samuels, *Letter Liturgy (for Leon)* (detail: *The Book of Alphabet Prayers*), 1993–1999. Mixed media: Desk, chair, audio recording, sound equipment, handmade book. 37 x 32 x 23 overall. Owned by the Carol and Arthur Goldberg Collection. Photographs courtesy of Aldrich Museum of Contemporary Art. Photographs by Catherine Vanaria. Courtesy of Kim Foster Gallery.

American art-book artists are women? Is this in part another creative response to centuries of exclusion from direct access to *The Book* that underlies Judaism?

One finally arrives back by way of letters and words mixed with images, to the beginning of a particular circle: that which opened the twentieth century with immigrant artists, mostly from Eastern Europe. Since the early 1970s, many new Jewish immigrants, particularly from the former USSR, have arrived in substantial numbers to these shores. Many brought with them the double question of how to survive between art acceptable to the regime and unacceptable, "unofficial," art and where to locate their Jewish identity in that in-between space—and found themselves asking how to reshape their identity in a new, American, context.

Grisha Bruskin

Grisha Bruskin (b. 1945) is one of the few "unofficial" Soviet artists whose work repeatedly alludes to his Jewish background. His paintings and works on paper (both before and after immigration to America) make repeated use of both Yiddish and Hebrew words (fig. 88). One is reminded of illuminated manuscripts in the marriage of text and image. Moreover, such works wed the penchant of Soviet protest artists to use text with that inclination among current Jewish American artists. "The Book is the world and the world is the Book," the artist commented in 1996, in explaining his visual obsession with the word. However, in a manner obliquely related to Diane Samuels' artist books, Bruskin's texts are usually quite cryptic—to read them is not necessarily to be able to *read* them—and in that sense resemble hieroglyphs as much as illuminations. The texts and images overrun each other, and only the initiate can read either.

His figures with human bodies and animal heads, or vice versa, remind one of works like the *Bird's Head Haggadah*, reflecting the fourteenth-century German Jewish fear of committing the sacrilege of emulating God's creativity too obviously. But they also bespeak the broader issue of being caught between worlds, between identities, between where and who the artist was and where and what he has become or will be.

Vitaly Komar and Alexander Melamid

Vitaly Komar (b. 1943) and Alexander Melamid (b. 1945) have been working in tandem since the 1960s and arrived in the United States in 1977. While still in the Soviet Union, they had created *SotsArt*, in 1972, as an allusion to American Pop Art and in mockery of socialist (*Sots*) propaganda and its art. They have been successful since their arrival here at capturing the interest of the American art public with their cleverly sarcastic plays on the icons of Soviet history and Euro-American history and art history. They refer to this work as "Anarchistic Synthesism," in which they place contemporary objects in archaic settings. In recent years they who visually toppled the sacred trinity of Marx, Lenin, and Stalin again and again in their paintings, have incorporated the images of those images toppled by the fists of *glasnost* into their artistic experimentation. In the last few years, they have also redefined themselves—not as Russians or Soviets or Americans or any narrow national or ethnic box into which others might place them. "We realized that we are, when all is said and done, *Jews*, as we migrate from one place to another and take root in one culture after another. The cosmopolitan tendencies of which our grandfathers would have been accused defines us, in the

Fig. 89.

Vitaly Komar and Alexander Melamid,
The Priest and the Teacher (detail),
1998. Mixed media. Courtesy Komar
and Melamid's archive.

most positive and dynamic way!"[39] *The Remains of the Temple* offers a crushed compendium of all that, as emigrants, they took with them from Russia, to Israel, and to the United States. The remains of an elongated pyramidal tower surmounted by a bright red Soviet Star—*The Temple of Komar and Melamid*—built and then crushed in a performance near the Hinnom valley outside the old walls of Jerusalem (and the remains of the suitcase burned in that performance, in which Komar's Soviet belongings had been carried out) are the tangible fragments of their former identity.[40]

With tongue firmly implanted in cheek, the pair followed their performance not only with textual play—they added a pun-filled "Book of the Komar and the Melamid"[41] to the Hebrew Bible between the Prophets and the Hagiographa, and carved a pair of small tombstones to underscore the death of their past selves—but with a series of paintings (fig. 89). The images, functioning as large illuminations for the text, are emphatically Christological. The two artists are portrayed as haloed saints, placed against a gold-leaf spaceless space background that draws specifically from the vocabulary of Russian icons.[42] The paintings' structures are elongated triangles—a geometric form (but rarely so elongated) that commonly refers to the trinity in the Christian visual tradition. Their garments are red and blue—colors that are standard symbols of sacrifice and truth in that tradition. But their omnipresent eyeglasses underscore the humorous backdrop of their intentions—identity and otherwise—and "benedictory" fingers are distorted to yield an elongated triangle that, like the shape of the paintings, recalls the structure that they built and crushed in the "sacrifice" outside Jerusalem.[43]

Michael Iofin

Michael Iofin (b. 1959) arrived in San Francisco only in the early 1990s. He is accomplished as both colorist and draftsman. Dream-visions that followed him from Petersburg to San Francisco include the 1991 to 1992 *Return to Jerusalem*, with its continuous urban landscape that shifts between worlds of snow-covered trees and palm trees, of suitcases and yellow stars, of angels and humans. By then the artist had left the Old World behind and was already reshaping himself within the new. Among the more interesting of Iofin's images is his water color and gouache *Portrait of My Parents* (1983–1984), which, while painted in Russia, is relevant to this discussion—which began and ends with immigrant artists painting their way into America (fig. 90). Its subject circles us back to the 1932 image by Raphael Soyer. Its style connects us to one of the significant responses to Soviet Socialist Realism by those wrestling themselves out of its constraints: parodying it

Fig. 90.

Michael Iofin (b. 1959), *Portrait of My Parents*, 1983–1984. Water color and tempera on paper. 30" x 20". Courtesy of the artist.

by carrying it to an extreme, overwhelming the viewer with myriad carefully wrought details, each laden with symbolic significance.

And its content pushes us along that trajectory of uncertainty as to how the world of which we are part fits together. Iofin's war-hero father, chest covered with medals, holds a letter from a Lithuanian writer—known for daring to write on the Holocaust in the early 1960s of Kruschev—who immigrated to Israel. Behind them, the blockade of Leningrad that killed so many in the winter of 1943 is balanced by the summer view of the small village of Rogochev, Byelorus, from which Iofin's father came—and where the Nazis massacred so many Jews. Before them, the yellow star and the cross flank the apple of Genesis: the combination of Jew and Christian has been nothing less than continuously tragic in Russian history. And if the chess piece and figurines and other objects and the old family photograph all bespeak the personal aspect of that history, the large watch on his father's wrist without hands or numbers reminds us that the issues and questions without answers are timeless, or at least as old as Judaism in a Christian world.

The question "whither, now, then?" pours out of the canvas at the viewer. It is the question that accompanied the artist to America and still clings to him, as it was the question that accompanied Jewish immigrants from Eastern Europe a century ago. The question has metamorphosed over the decades, and begotten other questions—but there are always questions. In looking back through this narrative, the common denominator has been that of *asking* questions—about the world and the place of artists, Jews, and Jewish artists within it. Questioning is by no means an exclusively Jewish art, but it is certainly one that is repeatedly exhibited by Jews. And certainly it encompasses the output of Jewish American painters in the twentieth century.

Introduction (pages 2–20)

1. This is what R. B. Kitaj does, for example, in his *First Diasporist Manifesto*. But the problem of defining "Jewish art" as "Diasporist art" is that he eliminates the "Jewish" from it. It is true that Jews share with Armenians, various African peoples, and Palestinians a history of dispersion, and that experience may well influence the art of members of all of these groups, but Kitaj then speaks of them as if they form one diasporist melting pot, putting us back where we began: What is unique (if anything) to the Jewish diasporist experience as opposed to the others?

2. The Jews of Hamburg, Germany, responded to this question by reshaping—re-forming—the ritual life of Judaism, trying to rid it of its "old-fashioned" elements. At virtually the same time, French Jews were busy asserting that Judaism is nothing *more* than a religion—not a nation or ethnic group—and that French Jews are thus Frenchmen who happen to be Jewish, not Jews who happen to live in France.

3. Camille Pissarro, *Lettres à son Fils Lucien*, ed. John Rewald (Paris, 1980).

4. Meyer Schapiro wrote that artistic creativity that pushes against prevailing aesthetic thinking is essentially Jewish, since by definition to be Jewish in the Christian world is to go against the spiritual tide. See Meyer Schapiro, "Race, Nationality and Art," *Art Front* 1 (March 1936): 10–12; and Donald Kuspit, "Meyer Schapiro's Jewish Unconscious," in *Jewish Identity in Modern Art History*, ed. Catherine M. Soussloff (University of California Press, 1999), 200–15, especially 204–205. Reprinted from *Prospects* 21 (1996): 491–508.

5. According to an alternative version of the story, it was the local rabbi's son who beat him, when he asked the rabbi to pose for him.

6. Carol Mann, *Modigliani* (New York & Toronto: Oxford University Press, 1980), 38–39.

7. And so the words written regarding him in summer 1919 by Lunia Czechowska, whom he depicted several times at that time: "He had so much to say that we would never leave each other. He spoke about Italy which he would never see again, about his daughter who he would never watch growing up but he never said a word about his art." Ibid., 182–92, esp. 192. Also see Jeanne Modigliani, *Modigliani: Man and Myth* (London and New York, 1959).

8. That Hebrew term means "digging beneath the surface" to ferret out meanings deeper than those on the surface of the text. This is what the artist has done visually to the Greek tale.

9. Indeed the work is based on an earlier *Prometheus and the Vulture*, an enormous (over 30 feet high) sculpture done in 1936 to decorate the Palace of Discovery and Invention at the Paris World Fair the following year. In that context it represented Science struggling against the forces of ignorance and Democracy against the fascist forces, the latter well-represented by the Nazi presence at the Fair. The victory, in France, of those very forces of Reaction the following year (1938) led to the destruction of the work. Both the sculpture and its dismantling were harbingers of things to come.

10. See *Memoirs from the Baths of Diocletian*, ed. Joseph Guttman and Stanley Chyet (Detroit: Wayne State University Press, 1975).

Part I: Immigrants and Artists (pages 22–50)

1. Irving Howe, "Americanizing the Greenhorns," and Norman L. Kleeblatt and Susan Chevlowe, "Painting a Place in America," in *Painting a Place in America: Jewish Artists in New York, 1900–1945*, exhibit catalogue, ed. Kleeblatt and Chevlowe, (The Jewish Museum, New York, 1991).

2. See Introduction, pages 5–6 and note 3.

3. Most of Gross's "Fantasy Drawings and Watercolors" were done from the 1940s until his death, and therefore fall after the time period discussed in this chapter. Indeed, those of the late forties and early fifties are, as April Paul, director of the Chaim Gross Studio Museum, points out, construable as part of his angry and anguished response to the Holocaust and his sense of devastation after the annihilation of his beloved older sister, Sarah, and her family. The image "Fisherman's Reveries" combines the phantasmagorical quality typical of these—albeit without the brutal quality that many of them offer—with elements that are virtually social realist in style, thus drawing from his early as well as later sensibilities.

4. Interviewed on camera in Segment 7B of the twenty-six-part video series *Tradition and Transformation: A History of Jewish Art and Architecture*, written, directed, and narrated by Ori Z. Soltes, produced by Electric Shadows Corporation, Cleveland, Ohio, 1984–1990.

5. Stieglitz's work reflects a visual relationship with the group of painters known as "The Eight"—Arthur Davies, William Glackens, Robert Henri, Ernest Lawson, George Luks, Maurice Prendergast, Everett Shinn, John Sloan—who exhibited together at Macbeth's Gallery in February, 1908, as a response to and protest against the aesthetic directions championed by the National Academy exhibition of spring 1907. Also known as the "Ash Can School" because of their humble subjects, they rejected the revolutionary visual directions being taken by artists in France and were the first group of American artists to have as a programmatic goal the shaping of a native style consistent with the American experience. By 1910, a second exhibition included works by George Bellows, Rockwell Kent, Edward Hopper, and Stuart Davis.

6. Over 1,600 works were exhibited, so that the combination of an array of new styles and sheer volume made a huge impact on the viewing audience.

7. See Barbara Rose, *American Art since 1900: A Critical History* (New York: Praeger Publishers, 1967), chapter 3.

8. Susan Crane, Introduction to exhibition catalogue, *Max Weber: The Cubist Decade, 1910–1920* (Atlanta, Georgia: High Museum of Art, 1991–1992), 13.

9. There is an irony in this. In turning from his avant-garde style to something more straightforwardly representational, he may have been turning his back on the *avant-garde* of *Western* Europe, but both the subject and style to which he turned was emphatically Old World—*Eastern* European—as opposed to *American.*

10. He would turn again toward an expressionist abstraction, even as he continued to produce genre works together with landscapes of majesty and richness in the 1940s and 1950s.

11. Max Weber, *Essays on Art* (New York: William Edwin Rudge, 1916), 48. And see Percy North, *Max Weber: American Modern*, exhibition catalogue (The Jewish Museum, New York, 1982), especially the introduction. As we shall later see (in Part II), the spirituality that he emphasized in his *Essays on Art*, in which he expounded on the mystical, or hidden, essence in all art, anticipates the mystical aspect buried in the underpinnings of the chromatic abstract expressionists whose work emerged in the 1950s.

12. Louis Lozowick, "A Jewish Art school," *Menorah Journal* 10 (November 1924): 466.

13. This attitude was being articulated at the same time that Weber was occupying himself more and more with explicitly Jewish themes.

14. Mary Austin, "New York: Dictator of American Criticism," *The Nation* 111 (31 July 1920): 129–30.

15. They were engaged in heated, sometimes public, discussions on the subject. Sculptor Willliam Zorach, for instance, who, while also born in Eastern Europe, grew up in Cleveland, and thus arrived to New York City in 1907 with more of a middle America sensibility than most of his colleagues, argued, differently from Lozowick, that it is the flavor of the country that would permeate an artist's work, if the artist drew "inspiration from his life and surroundings and belong[ed] as an artist first to that national [as opposed to local communal] life." This in a panel discussion held at the Whitney Museum of American Art in early 1932 and recorded as "Nationalism in Art: Is It an Advantage?" in *The Art Digest* 6 (15 March and 1 April 1932). In other words, not the community of the Lower East Side, but America at large should inspire the artist.

Moreover, since the primary object and subject of his discussion in making this comment were Jewish artists, he also observed that "painting Jewish types does not create Jewish art, nor concentration on the American scene make an American artist." Zorach thus explicitly entered the fray with respect to the dual question of what Jewish art is and what American art is—and whether a Jewish or other immigrant artist can produce "American" art.

16. The 1438 Panel, Prado Museum, Madrid, Spain.

17. See Maurice Samuel, *Blood Accusation: The Strange History of the Beiliss Case* (Philadelphia: Jewish Publicaton Society, 1966); and Bernard Malamud's novel *The Fixer* (New York: Farrar, Straus and Giroux, 1966).

18. Ben Shahn, *The Shape of Content* (Cambridge: Harvard University Press, 1957).

19. See the introduction to Leo Rosten, *The Joys of Yiddish* (New York: McGraw-Hill, 1968), especially pp. xxiv and xxx; and David A. Harris and Izrail Rabinovich, *The Jokes of Oppression: The Humor of Soviet Jews* (Northvale, New Jersey and London: Jason Aronson, Inc., 1988).

20. Rockefeller commissioned Diego Rivera to do a series of wall paintings that, when they were completed, were so detested by Rockefeller—he thought the imagery too Communist—that he actually had them destroyed.

21. Quoted in Frances K. Pohl, *Ben Shahn*, (San Francisco: Pomegranate Artbooks, 1993), 12.

22. In the fifteenth century, Leonbattista Alberti wrote a treatise on perspective in which, among other things, he discussed how to create the illusion in a two-dimensional work that the viewer is looking into space rather than at a flat surface. He defines with some precision the convergence of orthogonal lines spread out along the lower portion of the surface toward a point—along the horizon line or floor line in the upper half of the work—where they all meet (and disappear) at what he terms the "vanishing point."

23. In the Christian view of the realm beyond death, those consigned to hell but not so deeply that they are damned forever, can struggle and, over the aeons, eventually work themselves up through the painful spiritual cleansing—purgatory—that leads to paradise. But neither hell nor purgatory exist in the Jewish view.

24. A notable early example is his early turn to illustrating the Passover *Haggadah* (with its broad theme of freedom) on a grand scale (he worked on it for nearly fifteen years) and his concomitant focus on the calligraphy of Hebrew. Interestingly, from the early thirties to 1948 he abandoned his interest in Hebrew calligraphy. But perhaps inspired by the establishment of the State of Israel in that year, three years into the long aftermath of the Holocaust, he once again turned to Hebrew calligraphy. In the 1955 "Third Allegory," the Ten Commandments have been reduced to a series of single Hebrew letters (the first in each commandment)—both an allusion to a centuries' old means of conveying the image of the Decalogue by synecdoche and by referring to it as an allegory, reducing it to a mere symbol for an age stripped of its faith.

25. Rose, *American Art Since 1900*, 130.

26. In Eric Potter, ed., *Painters on Painting* (New York: Grossett & Dunlap, 1963), 244.

27. Stephen Robert Frankel, ed., *Jack Levine* (New York: Rizzoli International Publications, 1989), 20, in turn derived from various sources.

Part II: Between Representation and Abstraction (pages 52–89)

1. See, for example, Kleeblatt and Chevlowe, *Painting a Place in America*.

2. Ben-Zion collected hundreds of pebbles and painted them as faces and figures as a counterpoint to the bent nails and metallic detritus that became endlessly clever sculptures in his studio.

3. Interview with Ben-Zion by Barbara Shikler, 3 August 1982 (tape at the Archives of American Art) and from conversations with Lillian Ben-Zion throughout 1996–1997.

4. One recalls the single inward-looking eye of Modigliani's portraits, but Ben-Zion's Baal Shem appears to have no outward-looking eye. For images and more information on these works, see Tabitha Shalem and Ori Z. Soltes, *Ben-Zion: Song of One's Self. A Centenary Exhibition*, exhibition catalogue (Washington, D.C.: B'nai B'rith Klutznick National Jewish Museum, 1991).

5. Lionel Reiss, *My Models were Jews* (New York: The Gordon Press, 1938), Introduction.

6. The last portion of the book focused on life in a Palestine to which Jewish refugees would be strictly limited from entering by the British, except in small numbers, beginning the following year (1939). Ultimately Reiss would turn with perfect logic, as his next large project, to the varied and growing aspects of Palestine as, three years after the Holocaust, it became the State of Israel. To images of the twilight of Jewish Europe as it slid toward catastrophe he added those of the dawn of relocated Jewish life as it emerged in rebirth in *New Lights and Old Shadows*, published in 1954.

7. The chromatacists expressed this sense of conjoined interest in specific aspects of their secularized faith and broad-based humanistic matters in a series of manifestos during the developmental period of chromatic abstraction, noting that "if our titles recall the known myths of antiquity, we have used them again because they are eternal symbols. They are the symbols of man's primitive fears and motivations, no matter in which land, at what time, changing only in detail, but never in substance" Dore Ashton, *The New York School: A Cultural Reckoning* (New York: Penguin Books, 1972), 129.

8. See Genesis 1:3, "And God said: 'Let there be light.' And there was light"—which sets in motion the process that then separates the waters below from those above, and ultimately separates ordered heaven from chaotic earth.

9. Robert Doty and Diane Waldman, *Adolph Gottlieb* (New York: Whitney Museum of American Art and The Solomon R. Guggenheim Museum, 1968), 21–24.

10. See Barnett Newman's writings and manifestos from that era, and the discussions in *American Artists on Art from 1940 to 1980*, ed. Ellen H. Johnson (New York: Harper & Row, 1982), 19; Harold Rosenberg, *Art & Other Serious Matters* (Chicago and London: University of Chicago Press, 1985; reprint; original publication 1967), especially 268–69; and Ashton, *The New York School*, 72–73, 126–33. It must be noted that Ashton, quoting Thomas Hess's 1930s quoting of Newman, sees only an interest in anarchist politics in the artist's decision to learn Yiddish, the pre-eminent "Jewish" language of New York City in the 1930s. See also Thomas B. Hess, *Barnett Newman* (New Haven, Conn.: Eastern Press, 1971), especially 71.

11. Johnson, *American Artists on Art*, 31.

12. Per force, the illustration here comes from that later period. The roughly painted, cartoonish imagery referred both to personal events, such as the deaths of his father and brother (the latter after an auto accident), and to world events, from the Holocaust to Vietnam. See part III, note 6.

13. Cindy Nemser, "Interview with Helen Frankenthaler," *Arts Magazine*, November 1971.

14. Deborah Solomon, "Artful Survivor," *The New York Times Magazine*, 14 May 1989.

15. Listed as #29 in the *Catalogue Raisonné* by Diane Upright, *Morris Louis: The Complete Paintings* (New York: Harry N. Abrams, Inc., Publishers, 1985). The largely white against black image includes a six-pointed Star of David among its sweeping, scribbly white lines, with a rich, thick swirl of red and yellow wandering among them.

16. Louis's early interest in Rorschach—the codifier of the idea of subjective response and interpretation of abstract patterns of color and shape—is evidenced in an unpublished 1950 essay in which the artist talks about the viewer's interpretation as it pertains to line, color, and abstraction. See Diane Upright, 11.

17. Stuart Preston, "Sculpture and Paint," *The New York Times*, 26 April 1959, X17; Martica Sawin, "In the Galleries: Morris Louis," *Arts* 33 (May 1959): 59

18. See above, pages 57–60, and Rose, *American Art Since 1900*, 187–96; and James E. B. Breslin, *Mark Rothko: A Biography* (Chicago: University of Chicago Press, 1993), especially chapters 9 and 10.

19. Louis's letter is excerpted in Upright, *Morris Louis*, 15.

20. Only two of the *Unfurled* series were exhibited during Louis' lifetime, in an exhibition organized by Clement Greenberg at Bennington College, but Louis never saw the exhibit, as noted in Upright, *Morris Louis*, 21–22.

21. The *Stripe* series conceptually carries us back to the Greeks, transforming their sculptural concern (as articulated in the fifth century B.C.E. by Polykleitos) for a dynamic balance of imbalances—*symmetria*—created in part by opposing bent and straight, tensed and relaxed limbs, into the terms of painting. Louis would in fact extend the painted/unpainted dialogue still further late in 1961 with his turn to double-stack "Stripe" composition, and in 1962, shortly before his death, with narrower and more regularized patterns, creating even more of an illusion of endless vertical sweep. That summer he experimented yet further by turning them diagonally and horizontally.

22. Quoted in Matthew Baigell, *Jewish-American Artists and the Holocaust* (New Brunswick, N.J.: Rutgers University Press, 1997), 46, presumably quoting from Gerald Marzorati, *A Painter of Darkness: Leon Golub and Our Times* (New York: Penguin Books, 1990).

23. Baigell, *Jewish-American Artists*, 47.

24. In part this was due to the eerie echoes that resonated on the eve of the June 1967 Arab-Israeli war: Once again it appeared that large numbers of Jews were about to be annihilated while the world shrugged its shoulders, and American Jews as a whole could not ignore the seeming analogy to what had happened in the previous generation. In part it was the distance of a generation that opened the door, particularly for Survivor-artists, to enter that sacred and terrifying emotional territory.

25. R. B. Kitaj, "Jewish Art, Indictment and Defense," *Jewish Chronicle* color magazine, 30 November 1984.

26. Others have used the chimney in art with the same symbolic intent without verbally articulating it as such, including Lithuanian/Israeli/American painter Samuel Bak and Austrian painter Friedensreich Hundertwasser. The poet Nelly Sachs, who shared the Nobel Prize for literature in 1966 for her book *Oh The Chimneys!*, uses the image extensively in her writing.

27. "Wall Grid" is now located at the Wadsworth Athenaeum in Hartford, Connecticut.

28. This also links Rivers' work to the kind of medievalist sensibility of sacred timeless time in which two or more scenes are shown together in one register.

29. As Norman Kleeblatt observes in his essay "Metaphors on Matzah," in the exhibition catalogue *Larry Rivers' History of Matzah: The Story of the Jews* (New York: The Jewish Museum, 1984).

30. See Introduction, page 4, for a brief reference to Gottlieb, one of the most significant mid-nineteenth-century Eastern European Jewish painters, and renowned in his day as a portraitist, particularly of women.

Part III: Toward Century's End (pages 92–146)

1. Pearlstein was already eliminating the brush as he emerged into prominence in the 1960s, the time period of this part of the discussion. For a comparative work from that era, see for example his 1966 "Woman Reclining on Couch" in Rose, *American Art since 1900*.

2. One might argue that there is even further art historical irony in that, while leapfrogging over the process/technique-revealing innovations of Manet and the impressionists back to the Renaissance and Baroque periods, Pearlstein's sensibility is allied in part with Manet. It is as if he has synthesized *"le Déjeuner sur l'herbe"* (1863) with its female nudes/semi-nudes and "A Bar at the Folies-Bergère" (1882) with its mirror that reflects the male customer contemplating the bar-girl who is as much on display as the bottles and fruit at the bar, and both of which are part of the beginning of reconceiving the representational image as patterned abstraction.

3. Quoted in Ori Z. Soltes, *Figure and Fantasy: The Worlds of Gerald Wartofsky*, exhibition catalogue (Washington, D.C., B'nai B'rith Klutznick National Jewish Museum, 1995), 1.

4. See further discussion of these aspects of Wartofsky's work in Soltes, *Figure and Fantasy*, especially 6–7.

5. Quoted in Ori Z. Soltes, "Jewish Art? Judaic Content? Representational? Abstract?" exhibition essay (Washington, D.C.: B'nai B'rith Klutznick National Jewish Museum, 1997), 20.

6. In retrospect, it was, as noted above (part II, p. 70), Guston's new turn to figurative painting at the end of the 1960s that laid the groundwork for new image painting. He was driven in that direction himself because of "what was happening in America [in particular the Vietnam War], the brutality of the world. What kind of a man am I, sitting at home, reading magazines, going into a frustrated fury about everything—and then going into my studio *to adjust a red to a blue*. I thought there must be some way I could do something about it" (quoted in Irving Sandler, *Art of the Postmodern Era* [New York: Harper-Collins Publishers, Inc, 1996], 196). He had come to regard abstraction as "an escape from the true feelings we have," and by 1972 his rough-hewn figuration, focused on everyday objects and detritus—"junk for the junkman's son"—became both narrowly and broadly

self-referential: from allusions to the deaths of his father and brother to the Holocaust and its death camps. He is a crucial bridge from his own generation to the next, in both style and subject-concern.

7. See Ori Z. Soltes, "Words and Images: Lessons of the Holocaust," exhibition essay (Washington, D.C.: B'nai B'rith Klutznick National Jewish Museum, 1993). Kalb's work is based on photographs, and "anyone can understand these documents as reportage, but when I am selecting them I am looking for something else, something beyond the details of the incident which suggests to me the possibility that I might confront the viewer with a universal message."

8. In some respects, the most compelling of these is her 1993 *The Tracks*, which turns the visual discussion in several circles. The canvas presents a detail of what leads to the entrance of Auschwitz-Birkenau. We see the familiar shades of red and black for the earth and tracks. Part of a fence post, from which a fragment of barbed-wire extends, looms into the picture, offering the familiar yellow. The pieces and parts coincide to suggest the form of a Star of David. This most anonymous piece of God's earth—track, wire, post, dirt—is bursting with personalized anguish. For near this very spot is a small marker indicating the mass grave of sixteen individuals who were buried, a group that may have included Elyse's husband's grandfather.

9. For Solman, see Part II, page 57 (The Ten); for Sanabria's work see Ori Z. Soltes, "Spirit and Vision in Holocaust Art," exhibition essay (Washington, D.C.: B'nai B'rith Klutznick National Jewish Museum, 1995).

10. See Kiefer's stunning *ZimZum* (1990) at the National Gallery of Art, Washington, D.C., among other works. Kiefer also exemplifies the fact that the subject of the Holocaust also sometimes appears in the work of non-Jewish artists, particularly young ones from Germany and Austria. In this regard, one might also note the work of Beuys and Baselitz in the 1980s, or more recently, in the 2000 Whitney *Biennial*, work by Hans Haacke—who claims, however, that his work is not about the Holocaust! On Karver, see Soltes, "Spirit and Vision in Holocaust Art." On Liberman, see her book, *Holocaust Wall Hangings* (Boston: D & F Scott Publishers, Inc., 2002).

11. The work of Goodman and Katz is discussed together in Ori Z. Soltes's 1995 exhibition catalogue, *The Contents of History* (Washington, D.C.: B'nai B'rith Klutznick National Jewish Museum, 1995).

12. See Ori Z. Soltes, *A World of Family: The Works of Joyce Ellen Weinstein*, exhibition catalogue (Washington, D.C.: B'nai B'rith Klutznick National Jewish Museum, 1996), 22–24 and 12–14. Also see 30–33, which discuss her growing body of work relating directly to the Holocaust.

13. Artist's Statement for the exhibition *Jewish Artists: On the Edge*, curated by Ori Z. Soltes, Marian Art Center and Art Gallery of the College of Santa Fe, Santa Fe, New Mexico, 2000, Yeshiva University Museum, New York City, 2001. See also Soltes, *A World of Family*, section five: "Dead Boys."

14. For further information and a fuller sense of Gikow's range, see Matthew Josephson, *Ruth Gikow* (New York: Maecenas Press and Random House, 1970).

15. Ori Z. Soltes, "Susan Schwalb: The Creation Series," exhibition essay (Washington, D.C.: B'nai B'rith Klutznick National Jewish Museum, 1993), 11.

16. Aylon's and Hamoy's works therefore fall outside this discussion, but for more on Aylon, see *Faith: The Impact of Judeo-Christian Religion on Art at the Millennium*, exhibition catalogue (Ridgefield, Conn.: the Aldrich Museum of Contemporary Art, 2000), and Soltes, *Jewish Artists: On the Edge*. For Hamoy, see Ori Z. Soltes, *Textures of Identity*, exhibition catalogue (Washington, D.C.: B'nai B'rith Klutznick National Jewish Museum, 1995).

17. He became Sam Kaplan, courtesy of a schoolteacher for whom the original name was too cumbersome. But his great-grandson petitioned to restore the Kalmanovsky name in 1990!

18. That the youngest child, if it is a male, be named Benjamin is an old Jewish tradition that looks back to the time of biblical Jacob/Israel, whose youngest son was named Benjamin (cf. Genesis 35:18). In modern Hebrew, the word *benyameen* is not only a name, but means "youngest son."

19. The artist puns on the fringe at the painting's bottom: While it is the gold fringe of the American flag it also alludes to the symbolic fringe—the traditional *tzitzit*—that often peeks out from under a traditional Jewish male's shirt and pants. The artist later recalled how she was influenced by Arthur Szyk: "When I was eight or nine my parents gave me my own copy of Hans Christian Andersen's *Fairy Tales*, exquisitely illustrated by Arthur Szyk. I loved the stories . . . but, oh!, the pictures. The color, the birds and flowers and patterns . . . and the faces . . . there was something about those faces. . . . Years later I recognized the faces of Eastern Europe. In creating *Star of Local Kids*, the tribute to my grandfather's southern boyhood, I paid tribute, too, to the artist of my childhood—Arthur Szyk, illustrator and my grandfather, the scribe, became one—hand on the open page, finger pointing to 'the word'." (From a letter to the author). Szyk's illustrations of Andersen's *Fairy Tales*, done in 1944 were, in turn, a tribute to the Danish people as rescuers of Jews during the Holocaust.

20. There is more to this work, of course, from the discernible Star of David across the upper part of the arch to the manner in which the right-hand vertical support echoes the torso forms of her sculpture, with a half-moon "breast," a circular "belly," and a downward-triangle "pelvis." Thus the caryatid, which bridges architecture and sculpture, is further bridged to painting, but by means of Mordecai's own vocabulary.

21. Mordecai's more recent work continues her focus on archtypal "sacred" forms with a long history both Jewish and not. Her recent "Tree of Life/Ancient Sun" series, for instance, turns to imagery from a ceramic cult stand in the Israel Museum, in which seven circles are a key submotif and may be seen to extend, as a visual/spiritual idea, from Mesopotamian and Cana'anite art to the seven-branched menorah in Jewish art.

22. This began with his inclusion in the landmark 1985 exhibition of *New Horizons in American Art* at The Guggenheim Museum of Art, which was followed by a succession of exhibitions, both solo and group and culminated, in a sense, with his exhibit *Avoda: Objects of the Spirit* in 1999.

23. This is in part facilitated by his unique technique. Kahn begins by making a graphite drawing and then transfers that image in charcoal to a surface prepared with layers of gesso sanded to a smooth finish. He then paints the image in black and white to get a sense of its composition. Then he applies modeling paste as the base ground of the image, which is built up with layers of powdered pigment dissolved in an acrylic polymer medium. Whereas the bottom layers are likely to be rather opaque, those that follow are rendered more translucent by means of washes. A marvelous luminosity is the consequence of the gradations of paint and wash. One notes, as well, that the biomorphs derive, in part from his study of micrographic images; such a turn to and from science carries back to Pissarro (see my introduction, second section).

24. Artist's Statement for the exhibition *Jewish Artists: On the Edge*, Marian Art Center and Art Gallery of the College of Santa Fe, Santa Fe, New Mexico, 2000.

25. Fisher crosses the boundary of medium, as well, since she has also achieved such success as a photographer. Her photographic work has taken her to diverse places with a three-fold goal in mind. While visiting Israel several times since 1991, she turned to the austerity of its Negev desert, the timeless quality of which served as a boundless spiritual centering point for relocating in herself a sense of home by virtue of that Homeland. In photographing the remnant of Morocco's Jewish community in its Berber villages on the edge of the Sahara desert, particularly its elders and its children, she has explored memory and loss, as she has recorded one among the myriad ebb-and-flow phases of Jewish history. In photographing the tombs of Moroccan *tzadikim* (holy men, saints) that have become pilgrimage sites venerated by Jews and Muslims alike, and in living and photographing in a Belgian Catholic community, she has addressed that boundary between humanity and divinity as it is approached in common from different directions by different versions of faith.

26. Artist's Statement for the exhibition *Jewish Artists: On the Edge*.

27. Ibid.

28. Ibid.

29. See Ori Z. Soltes, *Intimations of Immortality: The Art of Moses Chaim Goldman, Robert Goldman and Michael Goldman*, exhibition catalogue (Washington, D.C.: B'nai B'rith Klutznick National Jewish Museum, 1992), especially 18–33.

30. These questions are echoes, of course, of the centuries-long question "What is Judaism?" with which the introduction to this book began, and its implications for the question "What is Jewish art?" As with Judaism throughout its history, the echoes always seem to offer new twists.

31. Known through most of her career as Andra Ellis, the artist assumed a new name several years ago; the first name reflecting her deeply enriched Jewish self-conscious and the second her marriage.

32. Quoted in Robert Rey, *Gauguin* (New York: Dodd, Mead and Co., 1924), 32. Rey's source is, in turn, Maurice Denis, *Theories of Symbolism and Gauguin to a New Classical Order* (Paris: Robert and Watelin, 1920). Denis is, in turn, quoting Sérusier, who was recalling an 1888 meeting of the Pouldu group at Pont-Aven, and Gauguin's influence on it.

33. Ori Z. Soltes, *Textures of Identity*, exhibition catalogue (Washington, D.C.: B'nai B'rith Klutznick National Jewish Museum, 1995), 7.

34. Ibid., 7.

35. Published too late for inclusion in this text, Shafner's work will soon appear in a book devoted to thirty-six of her Biblical images. The number is not accidental, since it plays on the Jewish mystical significance of that number, both as doubling the numerological symbol for "life" (eighteen) and offering the number (thirty-six) of "hidden righteous ones for whose sake the world continues to survive."

36. Zelda Shluker, "Too Jewish to be Hip?" *Hadassah Magazine* 79, no. 12, 1996.

37. Norman L. Kleeblatt, ed., *Too Jewish? Challenging Traditional Identities*, exhibition catalogue (New York: The Jewish Museum, 1996), ix–xi.

38. The Hassidic tale refers to the simple but pious man who prays: "Dear God, I do not know how to pray. But I can recite the alphabet. Please accept my letters and form them into prayers." (An alternate version has the simple and pious man explaining to the great mystic and scholar, Isaac Luria, that this is how he prays, when Luria inquires as to how and why his prayers are so effective. A third version has the *rebbe* reassure the simple and pious man that, if he keeps reciting the alphabet with strong and pure *intention*—the Hassidic term is *kavanah*—God will know how to formulate them into prayers.)

39. From a conversation with the author in January 2000. For further discussion of *The Sacrifice of the Third Temple*, see Soltes, *Jewish Artists: On the Edge.*

40. The Valley of Hinnom, a garbage dump during biblical times, is also known as *Gehenna*—it's as close to "hell" as the Hebraic tradition gets. The remnants of the performance there, including the remains of tools used to make and destroy the "Temple" and photographs documenting the event, were most recently exhibited in Santa Fe, New Mexico, and New York, New York, as part of the *Jewish Artists: On the Edge* exhibit (see above, Part III, footnote 13).

41. Among other things, this puns on their names: In Hebrew, *Komer* means "priest" and *Melamid* means "teacher."

42. The myriad images of them in the painting series calls to mind images of the pair of saints most specifically significant to the Slavic world, Cyril and Methodius. This ninth-century pair of brothers invented a new writing system, Cyrillic, to aid them in converting the Slavs to Christianity. Komar and Melamid, as it were, echo the process of carrying forth the Word, but with their own language and their own "writing" system.

43. Komar and Melamid are currently at work on an extended painting/collage series based on the image of the Star of David that would have been included in this discussion, were it complete at this time; it even more strongly reflects their recent thinking regarding their identity and its relationship to their art than any of their work heretofore.